DONCASTER
THEN & NOW
In Colour

GEOFFREY HOWSE

The
History
Press

This book is dedicated to the memory of my Uncle & Aunt
George & Martha (Pat) Nelder

First published in hardback 2011, this paperback edition 2015

The History Press
The Mill, Brimscombe Port
Stroud, Gloucestershire, GL5 2QG
www.thehistorypress.co.uk

British Library Cataloguing in Publication Data.
A catalogue record for this book is available from the British Library.

ISBN 978 0 7509 6497 5

Typesetting and origination by The History Press
Printed in China

CONTENTS

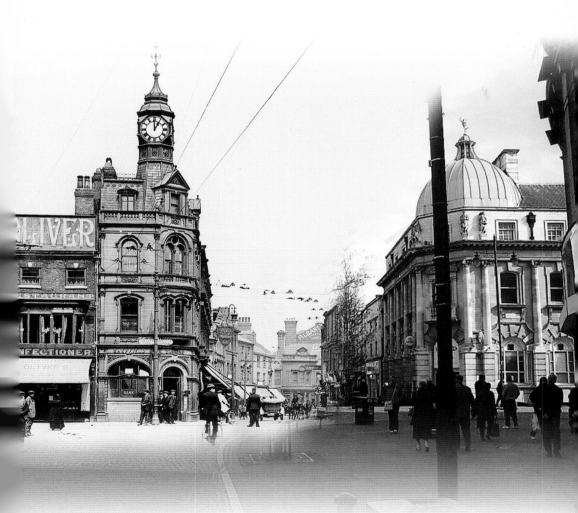

ACKNOWLEDGEMENTS

Iris Ackroyd, Mary Ackroyd, Stuart Ackroyd, Victoria Ackroyd, Jessica Andrews, Keith Atack, Vera Atack, Keith Bamforth, Marlene Bamforth, Michael Barber, Susan Barber, Caroline Bostwick, Daniel Bostwick, Fay Bostwick, Josh Bostwick, Laura Bostwick, Luke Bostwick, Neil Bostwick, Paul Bostwick, Sue Bostwick, Tony Briggs, Liz Burgess, Robert Burgess, Barry Crabtree, Kathleen Dale, Robert A. Dale, Iris Deller, Joanna C. Murray Deller, Ricky S. Deller, Tracy P. Deller, Christine Dulson, Gary Dulson, Angela Elliott, Brian Elliott, Joyce Finney, David Greenfield, Pamela Greenfield, George Hardy, Elaine Hickman, Steven Hickman, Ann Howse, Doreen Howse, Kathleen Howse, Raymond Mellor Jones, Alan Liptrot, Kristin Liptrot, Christine Johnson, Martyn Johnson, Michael Lambert, Doug McHale, Yvonne McHale, Bob Mortimer, Graham Noble, Tom Noble, Vale Noble, Barbara Nelder, Eleanor Nelder, Stanley Nelder, Terry Nelder, Anthony Richards, David J. Richardson, Lindy Stevenson, Michelle Tilling, Rose Vickers, Adam R. Walker, Anna Walker, Arthur O. Walker, Christine Walker, Darren J. Walker, Emma C. Walker, Ivan P. Walker, Jenny Walker, Paula L. Walker, Suki B. Walker, Thomas A. Walker, Walkers Newsagents (Hoyland), Lanza Watson, Paul T. Langley Welch, Clifford Willoughby, Margaret Willoughby, Betty Young, Roy Young, I would also like to thank John D. Murray who has assisted me over many years; and finally, not forgetting my ever-faithful walking companion, Coco.

ABOUT THE AUTHOR

Geoffrey Howse, actor, author and historian, was born in Sheffield and grew up in the South Yorkshire village of Elsecar. He has become well-known for his books and writing about Yorkshire subjects, including *A Century of Sheffield*, *Images of Sheffield*, *Sheffield Then & Now*, *Doncaster in Old Photographs*, *Doncaster Past & Present*, *Around Hoyland*, *Foul Deeds & Suspicious Deaths in South Yorkshire*, *The Wentworths of Wentworth & The Fitzwilliam (Wentworth) Estates*, and *The Little Book of Yorkshire*. His other books include: *Foul Deeds & Suspicious Deaths in London's East End*, *Foul Deeds & Suspicious Deaths in London's West End*, *The A-Z of London Murders* and *Murder & Mayhem in North London*.

INTRODUCTION

Doncaster's geographical location has made it an important centre in the north of England for centuries. Today Doncaster is the largest metropolitan borough in the country. The town's location was recognised as being of considerable importance when the Roman fort of Danum was built. The continued use of the name Danum in various buildings and streets throughout the area serves as a reminder that the Romans once held sway here. The town was called Don Ceastre by the Saxons, (their word 'ceastre' referring to a Roman fort) from which the present name for the town is derived. A small fragment of the Roman fort remains but there is nothing left of the Norman castle which was built on its site, as this was replaced by the medieval church of St George, built around 1230 and destroyed by fire in 1853. Sir Gilbert Scott's masterpiece, the present-day St George's church, raised to Minster status in 2004, was built on the site of the old church and opened in 1858. It closely resembles the original.

Despite the almost wholesale obliteration of many of Doncaster's fine architectural features, the town – which has an extremely poor record for preserving historic or architecturally important buildings – still has a great deal to offer. Although much of its rich architectural history has gone, Doncaster can still boast a spectacular array of buildings from various periods, even though so many of the town's ancient buildings have been destroyed over the last hundred years or so.

Doncaster experienced considerable expansion during the Georgian period and its buildings are all the better for it. The town then increased in importance when it became a major railway centre during the mid-nineteenth century. Sadly, the early years of the twentieth century saw some of Doncaster's finest buildings consigned to rubble. Even one of Doncaster's rivers did not escape being tampered with. The River Cheswold, a tributary of the Don, was culverted during the second and third decade of the twentieth century and its existence is largely forgotten by the majority of today's Doncaster residents. As recently as the 1960s Doncaster's architectural gems were still being torn down. Thanks to the Doncaster Civic Trust, which published a report in 1973, recommending the establishment of conservation areas within the town centre, further vandalism was prevented.

The older images in this book are the work of many photographers. However, there was one in particular who based himself in Doncaster and captured through his lens much more than any other. Edgar Leonard Scrivens (1883–1950) obtained his first camera while still a schoolboy and there began a love of photography which remained with him for the rest of his life. His extensive library of postcard views covered diverse scenes in virtually every town and village within a 40-mile radius of the town.

I have chosen a selection of images of old Doncaster, some dating back more than 130 years, which among many other interesting subjects, show several of the town's architecturally important or popular features, which have long since disappeared. Some were demolished during the creation of new thoroughfares, others during the wholesale destruction which Doncaster suffered for the best part of a century. There have been some splendid additions to Doncaster's great architectural heritage in recent years. The modern views, showing the same location as that in the old image and taken from the same spot, clearly illustrate just how dramatic some of the changes to Doncaster have been.

Geoffrey Howse, 2011

MINSTER CHURCH OF
ST GEORGE

A SCRIVENS POSTCARD view of St George's church from the north bank of the River Don. For centuries the medieval church, built *c.* 1200, dominated the Doncaster townscape. A disastrous fire destroyed the old church in 1853. The present church of 1858 was built to the design of

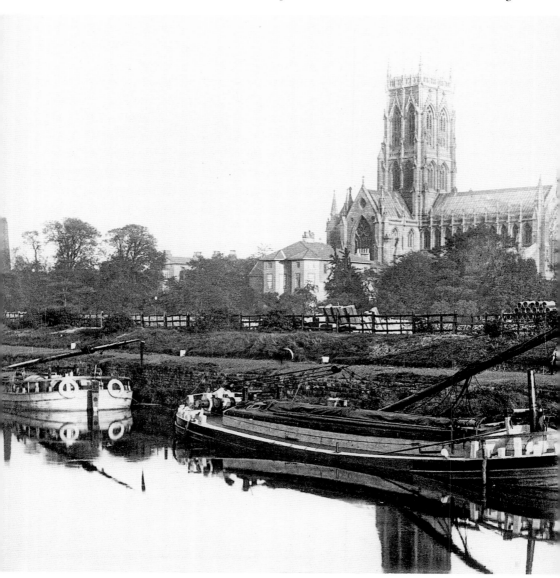

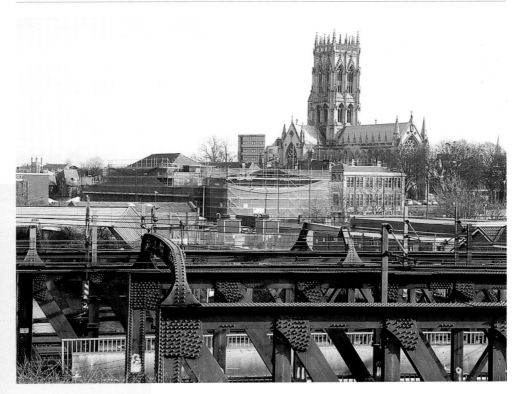

Sir George Gilbert Scott in magnesium limestone and closely resembles the old building. Its magnificent 170ft-high central tower is a prominent feature.

ON 17 JUNE 2004 The Rt Revd Jack Nicholls, Bishop of Sheffield granted St George's church minster status ('minster' in English refers to a particularly important church. The term is also used for a cathedral, such as York Minster and Southwell Minster). This view, taken from the North Bridge, as close as I was able to get to Scrivens' viewing point of about a century ago, shows the Minster Church of St George in February 2011.

ST GEORGE GATE

A LATE NINETEENTH-CENTURY view of St George Gate. The clothiers and hatters, Blackburns, can be seen in the left foreground, next door is the plumbing business run by Wright. 'Gate' is a feature in several Doncaster street names. The use of the word 'gate' in this context does not actually mean a gate in the sense of it being the gateway to anything in particular; it is an Old Danish word which simply means 'street'.

ST GEORGE GATE seen here in February 2011 (right). St George Gate, once a direct route between the town centre and the parish church, almost disappeared when the ring road was constructed

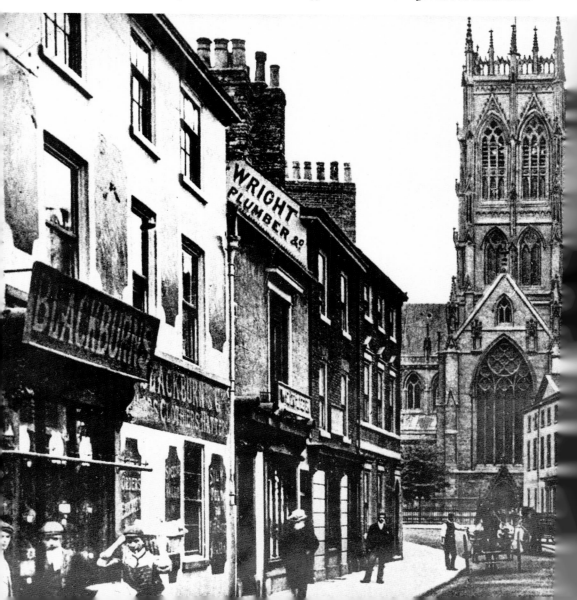

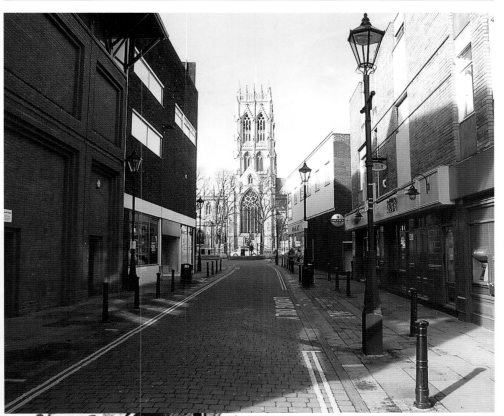

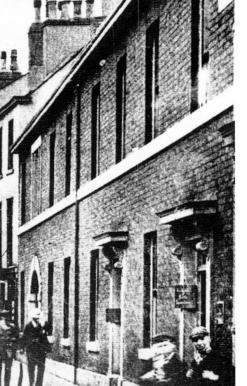

in the early 1960s. Most of St George Gate was engulfed by the part of the ring road known as Church Way. Typically, the modern buildings are out of keeping with their immediate surroundings. In the left foreground, fronting on to Baxter Gate, is a charity shop, the British Heart Foundation, and a little further along is a side exit from the House of Fraser outlet store, which also fronts on to Baxter Gate. On the right at the corner of Baxter Gate is a branch of the Santander bank. Next door, with the bright yellow frontage is the Vintage Rock Bar and occupying the building on the extreme right is a branch of Primark.

9

ST GEORGE GATE AND BAXTER GATE

THE JUNCTION OF St George Gate with Baxter Gate, *c.* 1885, featuring the distinctive Dutch style gable of Beetham's Wine and Spirit Merchants.

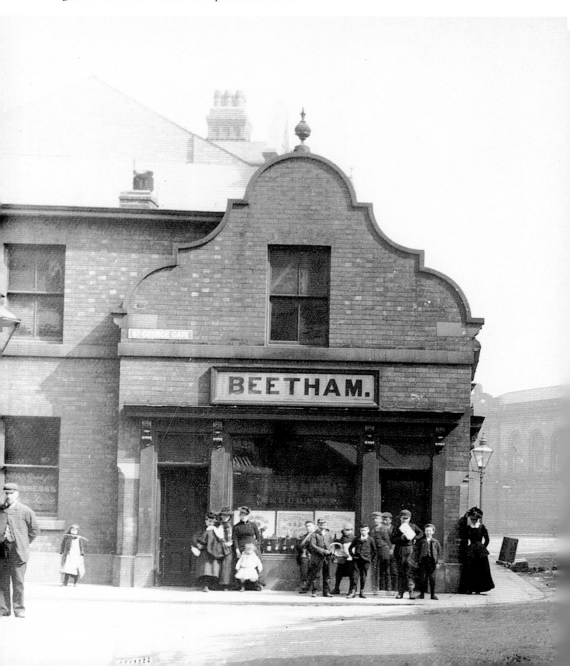

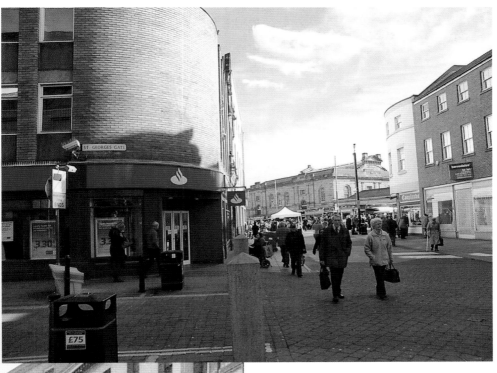

THE SITE OF Beetham's shop is presently occupied by the Santander bank. On the right, at the corner of Baxter Gate fronting Market Place, is a branch of the well-known baker's Cooplands. In 1932 Mrs Alice Jenkinson (born Alice Coopland in Scarborough) opened a shop at 33 Hall Gate, in which she sold homemade cakes and chocolates. Such was the demand for Mrs Jenkinson's products that within a year it became necessary for her to employ a full-time baker and increase the range of her goods, and the company that she had established gradually expanded. Mrs Jenkinson died in 1953 and today the business has branches spread across a wide area. Cooplands continues to be a family-run business with several family members involved in the day-to-day running, including the founder's son, Mr David Jenkinson, who is the company president.

11

ST GEORGE GATE AND BAXTER GATE CONTINUED

THE PREMISES OF Beetham's Wine and Spirit Merchants were partially replaced in 1894, with this impressive stone-faced, curved-corner frontage and an arched and corbelled first-floor window, above which was inscribed the name 'BEETHAM', with a date stone placed between an ornately balustraded parapet. This building survived for the better part of a century.

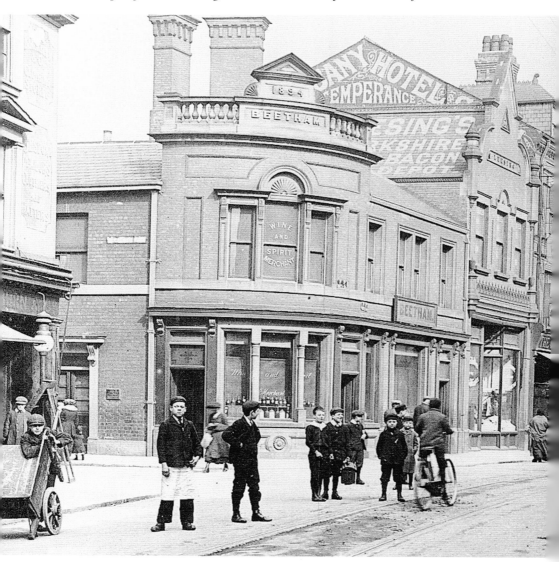

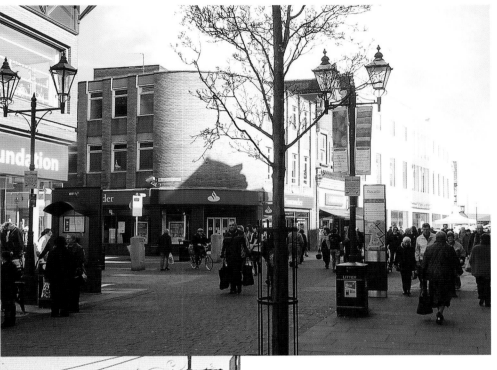

THE MODERN BUILDING on the corner of St George Gate and Baxter Gate follows the same line of curvature as the building it replaced. Formerly occupied by the Alliance & Leicester building society, it is now occupied by the Santander bank. An important survival in Baxter Gate is the attractive narrow Victorian brick building with ornate gable and decorative iron and stonework, which is situated next door at No. 35. Presently occupied by an outlet of the ubiquitous Greggs the bakers, it was built in 1894 for Leesing's, a noted pork butcher. Although David Leesing was killed in 1901, successive owners of his former business traded under the name Leesing's until 1980. The building subsequently became The Baker's Oven, whose nationwide chain of 424 shops was taken over by Greggs in 1994.

BAXTER GATE

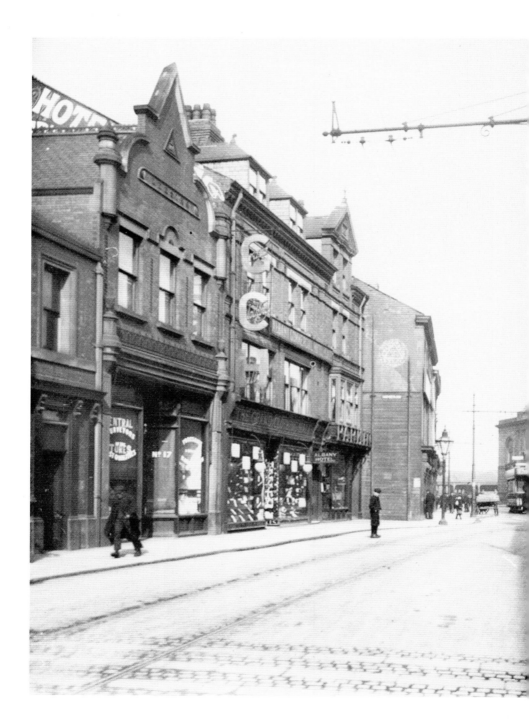

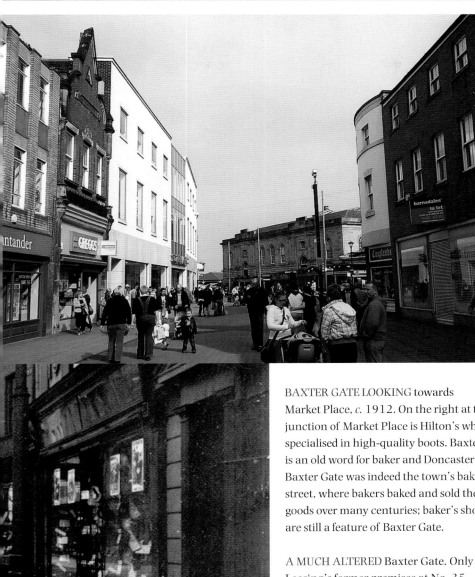

BAXTER GATE LOOKING towards
Market Place, *c.* 1912. On the right at the
junction of Market Place is Hilton's who
specialised in high-quality boots. Baxter
is an old word for baker and Doncaster's
Baxter Gate was indeed the town's bakers'
street, where bakers baked and sold their
goods over many centuries; baker's shops
are still a feature of Baxter Gate.

A MUCH ALTERED Baxter Gate. Only
Leesing's former premises at No. 35
(now Greggs the bakers) and the Market
Hall are recognisable from the *c.* 1912
photograph. Baxter Gate in years gone
by was a much narrower thoroughfare;
the widening of the street took place
in the late nineteenth century, when
several buildings were demolished and
the new ones that replaced them were
set back.

FRENCH GATE

THE GUILDHALL, c. 1890. One of Doncaster's most distinctive classical buildings, the Guildhall, was built in French Gate in 1847 on the site of the original Angel & Royal Hotel (demolished 1846). Astonishingly, and much to the regret of many Doncaster residents, the Guildhall was

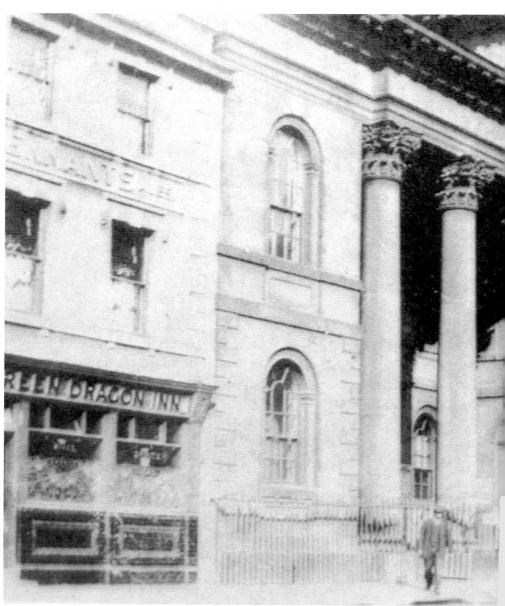

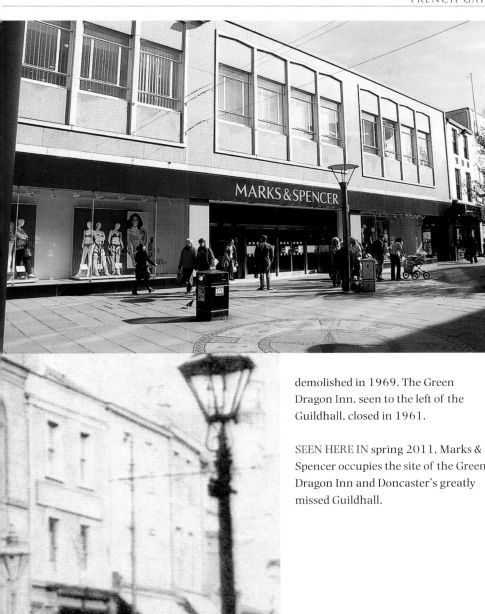

demolished in 1969. The Green Dragon Inn, seen to the left of the Guildhall, closed in 1961.

SEEN HERE IN spring 2011, Marks & Spencer occupies the site of the Green Dragon Inn and Doncaster's greatly missed Guildhall.

17

CLOCK CORNER

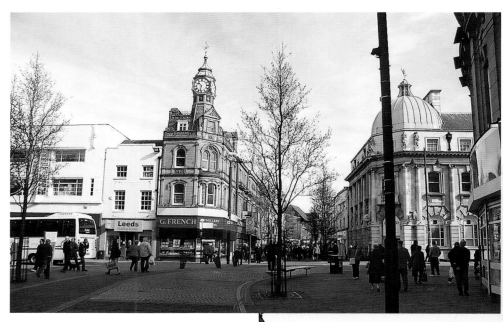

CLOCK CORNER SEEN from St Sepulchre Gate, *c.* 1920 (right). French Gate goes off to the left, High Street to the right, and Baxter Gate is straight ahead. The building with the large dome is the Midland Bank, at No. 1 High Street, built in 1897 and designed by York architect W.H. Brierley (1862–1926) in the English Baroque style. The building on the left with the clock tower replaced an earlier building which also incorporated a clock (seen on p.20). In 1895 a new building incorporating a clock tower was constructed at the corner of French Gate and the newly widened Baxter Gate, to the designs of the architect J.G. Walker (1850–1930), who was born in the old building at Clock Corner. He designed this building as his own offices, resulting in the County Fire Office and J.G. Walker's ironmonger's being demolished. When this photograph was taken part of

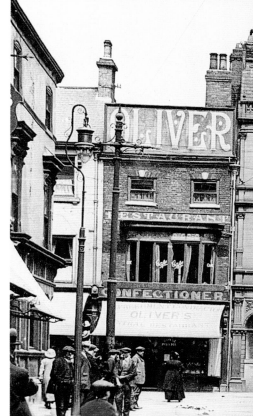

J.G. Walker's building was occupied as a bank. Shortly afterwards it became a branch of Burtons' the tailors.
(*Courtesy of Chris Sharp*)

CLOCK CORNER TODAY (left) is still regarded as an important landmark by many of Doncaster's residents. J.G. Walker's 1895 building remains substantially unaltered. Unlike many shopfronts in the vicinity, the jeweller G. French's blends in reasonably well on the ground floor of the late Victorian structure it occupies. Clock Corner's Westminster chimes ring out every fifteen minutes. The quasi art deco building with Crittall windows to the left of Leeds Building Society (formerly Oliver's restaurant) in French Gate, was replaced by early nineteenth-century buildings.

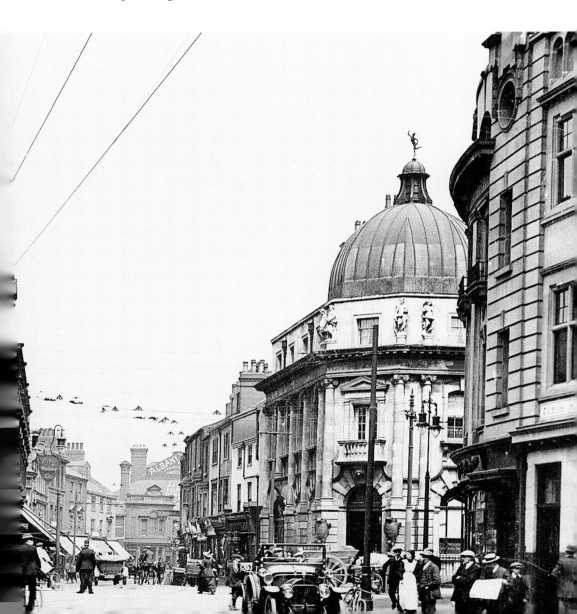

FRENCH GATE, HIGH STREET, BAXTER GATE AND CLOCK CORNER

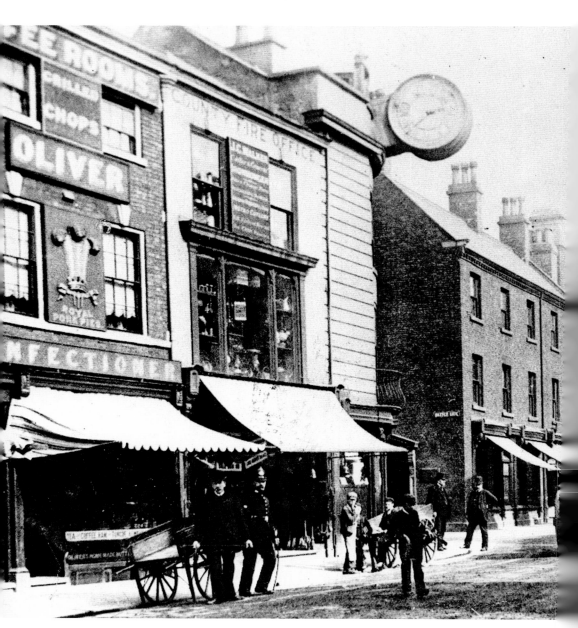

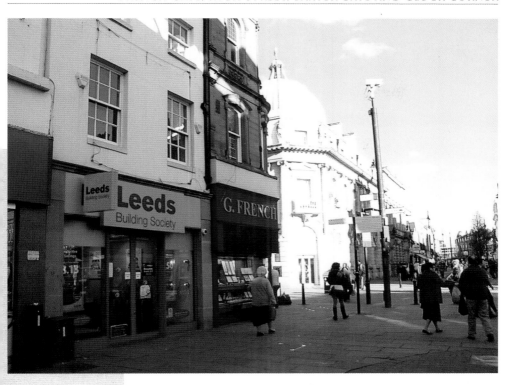

FRENCH GATE AND High Street, 1894. The narrow opening on the left at the junction of French Gate and High Street is Baxter Gate. Seen in the left foreground, Oliver's coffee rooms and their shop were noted for royal pork pies and all kinds of cakes, gingerbread and parkin. The County Fire Office provided insurance and the ironmonger, J.C. Walker, was next door at Clock Corner. Across Baxter Gate in High Street were other shops, including G. Parkinson, boot and shoe maker; Leo Walker, basket maker and F. Lummand, who made fancy chairs and wicker perambulators. The water cart seen crossing the end of Baxter Gate ran up and down the street daily, watering the dusty road. Many of these buildings were pulled down when Baxter Gate was widened, shortly after this photograph was taken. The clock seen in this photograph was taken down and incorporated in a building in Sunny Bar.
(*Barry Crabtree Collection*)

OLIVER'S OLD PREMISES are today occupied by Leeds Building Society. When Baxter Gate was widened in 1894/5 the present building at Clock Corner was built. G. French, the jeweller's, occupy the ground floor trading premises of the building which today covers a narrower site than that which once housed the County Fire Office and Walker's ironmongers.

HIGH STREET FROM HALL GATE

HIGH STREET FROM Hall Gate, *c.* 1875 (right). On the left, just before the scaffolding, is Doncaster's celebrated Mansion House, one of only three in England (the other two are in London and York). The Mansion House was designed in 1744 by James Paine and was built at a cost of £4,523 4*s* 6*d*, for use as the mayor's residence. James Paine (1716–89) was a fashionable architect who worked in the neo-Palladian style. He worked on several country mansions in the Doncaster area, including the wings of Cusworth Hall, Serlby Hall, Sandbeck Hall and Wadworth Hall. Work commenced in the summer of 1744 but was delayed owing to the rebellion in Scotland; the Mansion House was ready for occupation by 1750. It contains a splendid suite of rooms, including reception room, ballroom, banqueting room and salons. No longer the mayor's residence, the Mansion House is still used for civic functions and other council business. It is a Grade I listed building.
(*Barry Crabtree Collection*)

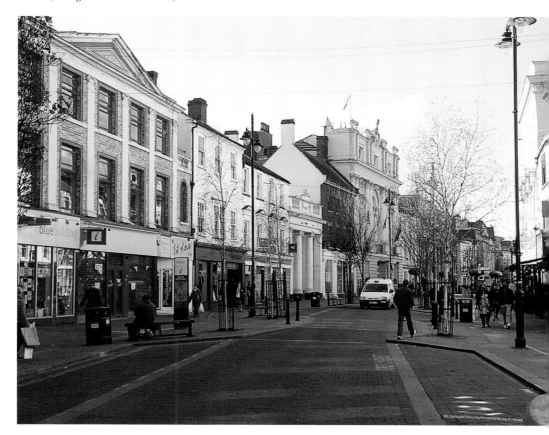

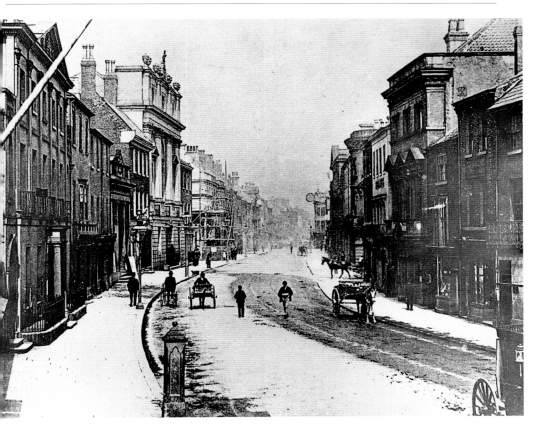

SITUATED AT NOS 38–40 High Street (left), the distinctive pedimented Georgian façade in the left foreground of what is currently known as the Blue Building was designed by local architect William Lindley (1739–1818), who for twenty years was assistant to the eminent Yorkshire architect John Carr. Originally built as a wine merchant's, the building served as the New Bank between 1812 and 1847. Blue and gold mosaic tiles were added in 1924, during the building's tenure by the Refuge Assurance Company (the choice of colours for the tiles, it is believed, stems from the colours of the firm's livery). Today the Blue Building principally serves as the Tourist Information Centre. The façade is the only part of the building that is not completely modern. A little further down the street, the pillared entrance, with its Ionic columns, once formed the portico of the Subscription Rooms, built as Betting Rooms in connection with Doncaster Racecourse. Designed by Messrs Woodhead and Hurst in 1826, the portico is all that survives of the original structure and during part of the twentieth century served as the entrance to the Picture House, later the Savoy cinema. The remaining parts of the building were demolished in 1974. Today the portico forms the entrance to Priory Walk, which comprises shops, bars and a public house.

HIGH STREET FROM CLEVELAND STREET

LOOKING UP HIGH Street from the junction of Cleveland Street in the 1920s. Bassett Motors Ltd's premises are in the right foreground and the Lyceum Restaurant can be seen opposite the Mansion House. The Danum Hotel on the left, which opened in September 1910, replaced the old

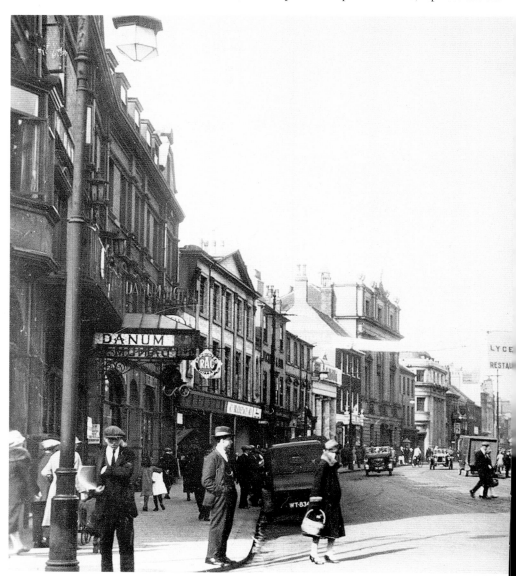

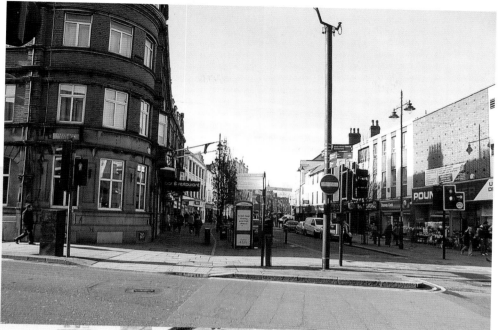

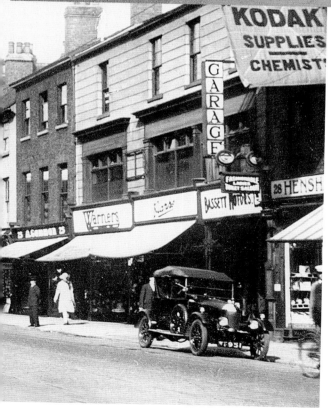

Ram Hotel, a former coaching inn, demolished during the Edwardian period. (*Courtesy of Chris Sharp*)

HIGH STREET IS a much narrower thoroughfare for traffic than in days gone by. Now a one-way street, it is significantly more pedestrian friendly, with wide pavements. Regrettably several old buildings on the right have been replaced by appallingly architecturally unsympathetic modern buildings which are completely at odds with their more elegant neighbours.

HIGH STREET TOWARDS HALL GATE

HIGH STREET LOOKING towards Hall Gate in the 1920s ; a reverse view of the previous two images. The Danum Hotel, seen on the right, had by this time become well established in the town. (*Courtesy of Chris Sharp*)

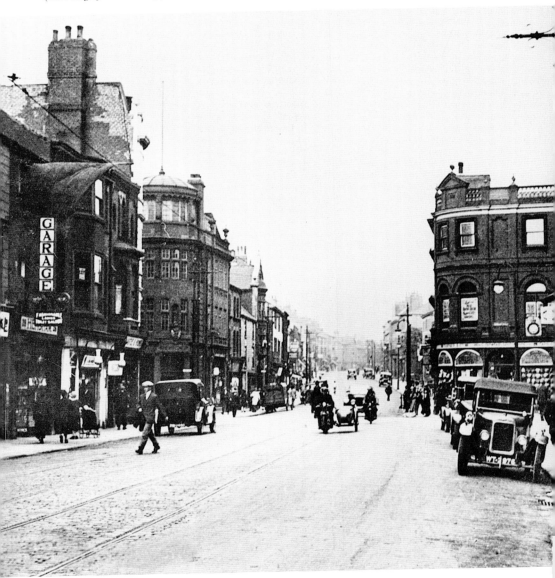

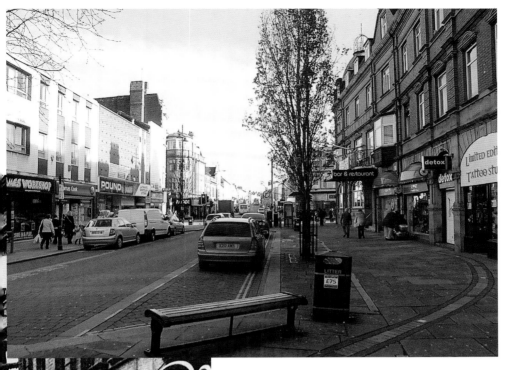

IT IS MUCH to Doncaster's shame that poorly designed, unattractive and utilitarian modern buildings have replaced better-designed and better-built old structures within a stone's throw of not only the Mansion House but also the town's oldest surviving building.

HIGH STREET FROM HALL GATE

HIGH STREET c. 1930, seen from Hall Gate. The Reindeer Hotel, on the left, one of the town's many popular meeting places, stands at the corner of Cleveland Street. Across Cleveland Street is the Danum Hotel, which contains sixty-four en-suite rooms, and beyond that, the last building to be seen in High Street itself, is the Mansion House.

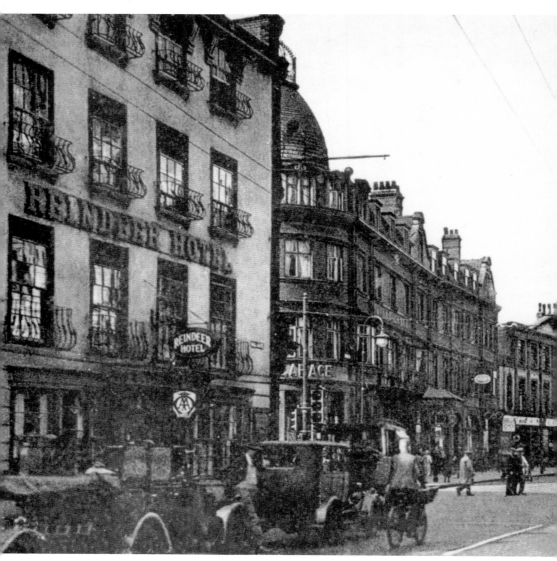

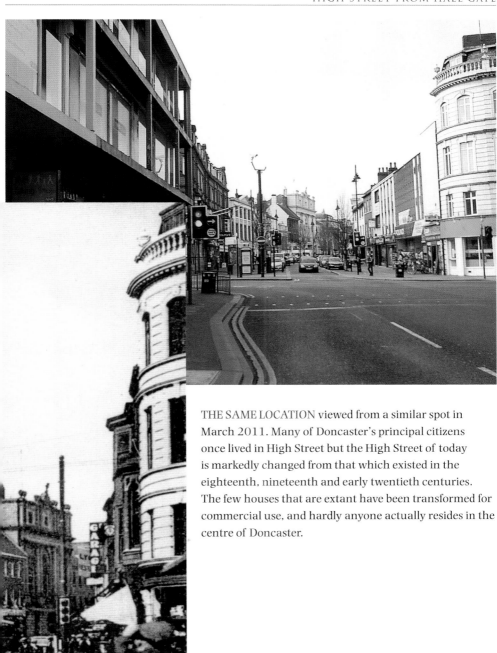

THE SAME LOCATION viewed from a similar spot in March 2011. Many of Doncaster's principal citizens once lived in High Street but the High Street of today is markedly changed from that which existed in the eighteenth, nineteenth and early twentieth centuries. The few houses that are extant have been transformed for commercial use, and hardly anyone actually resides in the centre of Doncaster.

THE REINDEER HOTEL

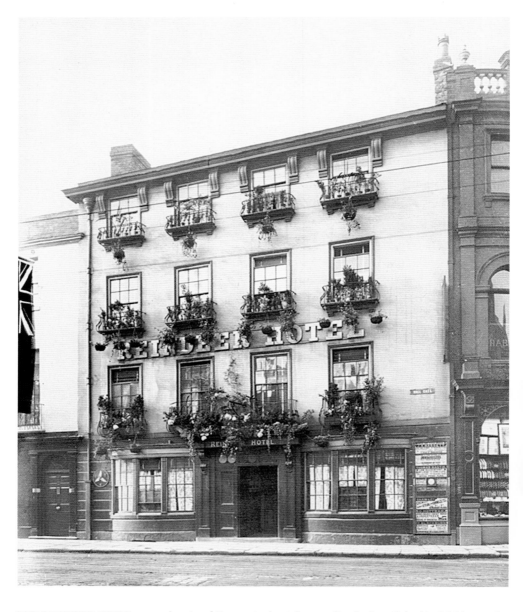

THE REINDEER HOTEL, a much-missed Doncaster hostelry, needlessly demolished in 1962, stood at the Hall Gate/High Street junction of Cleveland Street, from at least as early as 1782. This photograph dates from the early twentieth century.
(*Barry Crabtree Collection*)

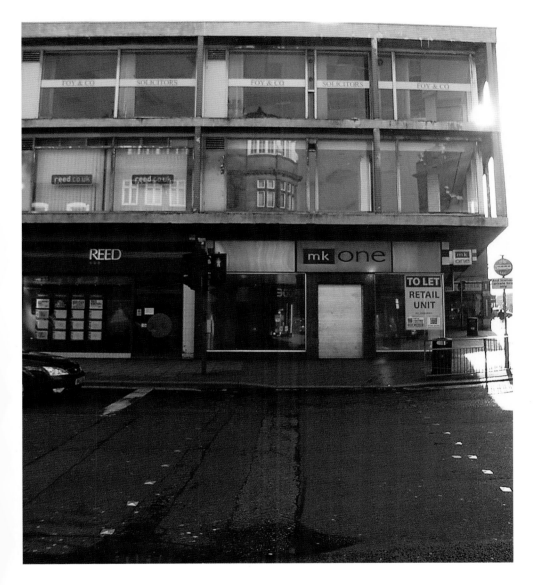

THE BUILDING WHICH replaced the Reindeer Hotel, seen here in 2011. Well, what can one say? On reflection, I think it is probably better to let the photograph speak for itself.

HIGH STREET AND CLOCK CORNER

HIGH STREET IN 1905, looking towards Clock Corner. Samuel Parkinson, pastry cook and confectioner, opened his business in the premises seen here in the left foreground, at 50–51 High Street in 1817. Parkinson's were famous for their baking powder and perhaps more significantly, for their butterscotch. The word butterscotch was first recorded in Doncaster when Samuel Parkinson began production of the candy in 1817. Following a visit by Queen Victoria to Doncaster in 1851, Parkinson's supplied butterscotch to the court and royal household until the business closed. Although Parkinson's vacated their High Street premises in 1960, production of Parkinson's Butterscotch continued until 1977.

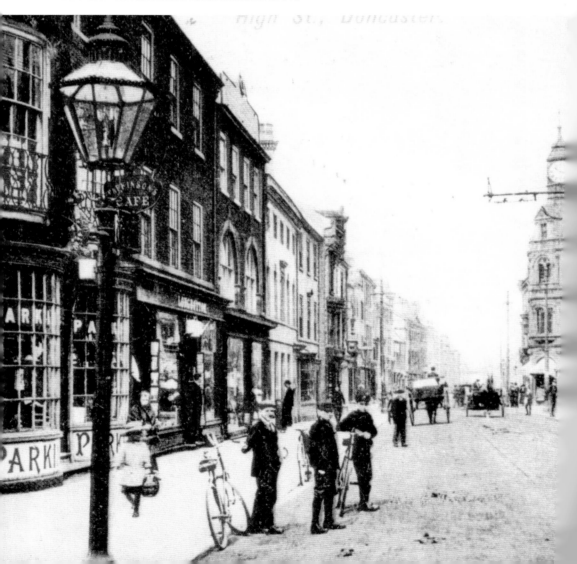

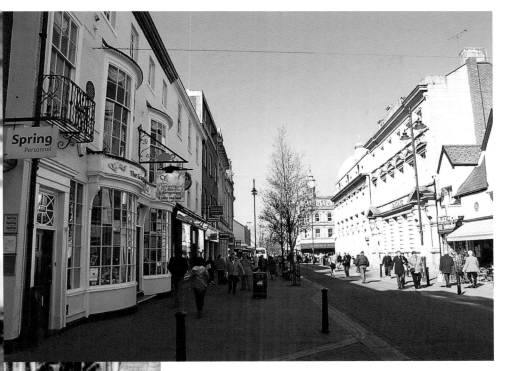

FORTUNATELY, THE GEORGIAN building with the distinctive bow windows, painted brick front and Welsh slate roof, Samuel Parkinson's former premises, has survived. Popularly known as 'Upstairs Downstairs', it was (not unusually, when one considers Doncaster's fairly recent history), under threat of demolition. Thanks to Doncaster Civic Trust, the building was saved and restored in 1976. It is worth considering that during the eighteenth century Doncaster's High Street was regarded as the finest on the road between London and Edinburgh. The loss of far too many fine buildings replaced by inappropriate structures is only too noticeable. A greatly admired feature of High Street, nos 50–51 currently serve as the Georgian Tea Rooms & Restaurant. In the right foreground can be seen part of Doncaster's oldest surviving building, which dates from the sixteenth century.

HIGH STREET

HIGH STREET c. 1908. A reverse view of the previous two images. On the left can be seen J.C. Bell's jeweller's and beyond Parkinson's Café on the right, at No. 49, is R.H. Hepworth's Borough Printing Works, which incorporated his Circulating Library.

DESPITE ITS OBVIOUS architectural and historic importance, the Doncaster High Street of today is littered with inappropriate shopfronts which mar and severely compromise their

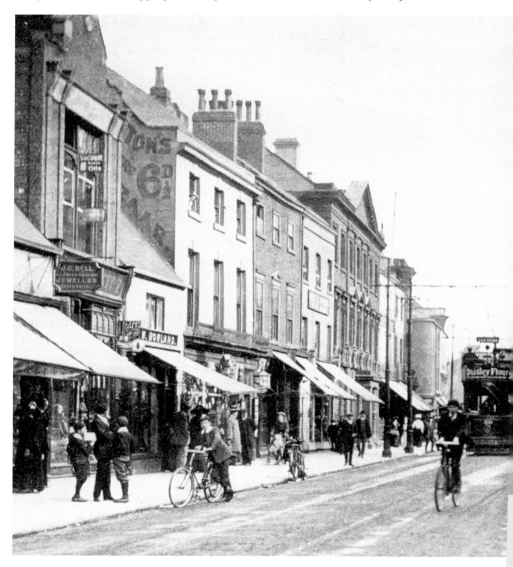

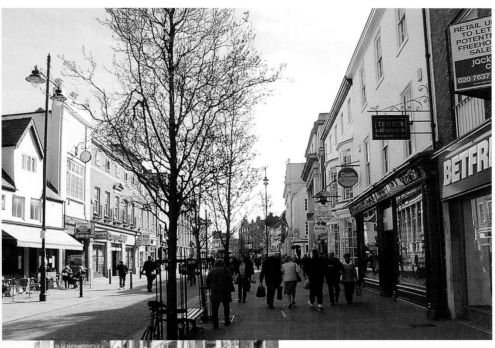

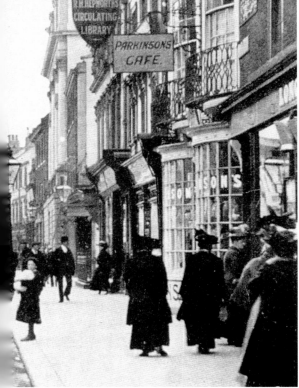

building's integrity. Some fine buildings have fared better than others. This photograph shows a good view of the town's oldest building. No. 6 High Street, seen on the left, with its canvas canopy and pavement tables and chairs, reputedly dates from the sixteenth century and is currently a food outlet, the Cornish Pasty Company Ltd.

STATION ROAD

STATION ROAD C. 1905. On the left is the Doncaster Mutual Co-operative & Industrial Society Ltd. Established in 1868, by 1911 it was advertising a membership of 13,000, had a share capital valued at £126,000 and annual sales of over £314,000. In the centre is the Glyn Commercial Hotel, constructed in 1890 and named after the Revd Edward Carr Glynn, vicar of St George's and a principal promoter of the temperance movement in Doncaster. The Grand Theatre can be seen at the end of the road. Station Road was the terminus for several tram routes.
(*Courtesy of Chris Sharp*)

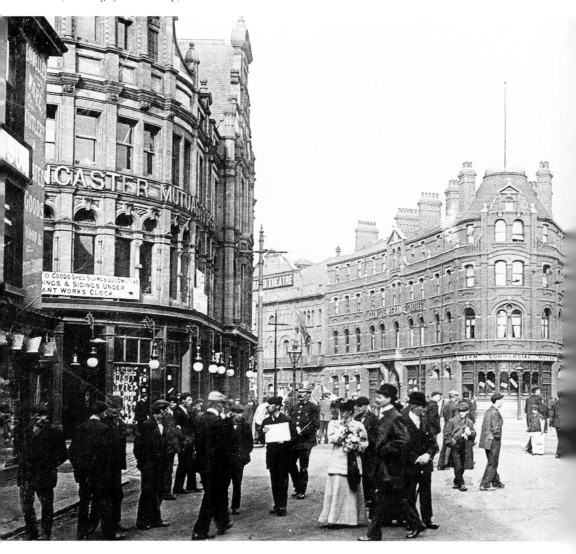

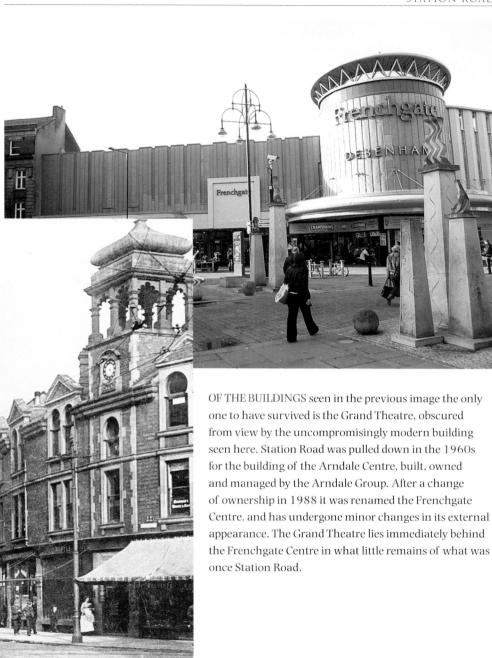

OF THE BUILDINGS seen in the previous image the only one to have survived is the Grand Theatre, obscured from view by the uncompromisingly modern building seen here. Station Road was pulled down in the 1960s for the building of the Arndale Centre, built, owned and managed by the Arndale Group. After a change of ownership in 1988 it was renamed the Frenchgate Centre. and has undergone minor changes in its external appearance. The Grand Theatre lies immediately behind the Frenchgate Centre in what little remains of what was once Station Road.

THE GRAND THEATRE, STATION ROAD

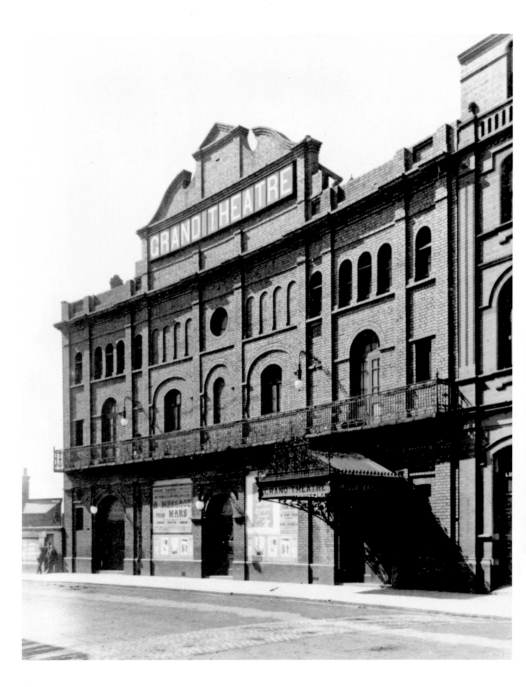

THE GRAND THEATRE, Station Road, Doncaster opened on 27 March 1899 with a production of 'La Poupee', transferred from London's Prince of Wales Theatre. Built by local builders Arnold & Sons and designed in a delicate 1890s interpretation of a Regency theatre by the noted theatre architect John Priestley Briggs FRIBA (1869–1944), the Grand Theatre was completed and opened over two years before Station Road itself was finished and officially opened. In 1947 the Essoldo chain of cinemas took over the running of the theatre, continuing to run it as a live theatre until 28 July 1958, when it became a cinema. The Grand's life as a cinema was only brief however, as it reverted to live performances on 21 September 1959. In 1961 it became a bingo hall and remained in use for that purpose until 1995. A year earlier the Grand Theatre had been given Grade II listed status. Since bingo stopped being played there, the building has stood empty and has been threatened with redevelopment on more than one occasion. Fortunately, the Friends of Doncaster Grand Theatre are in the process of raising funds with the intention of restoring this glorious theatre and returning it to full theatrical use.

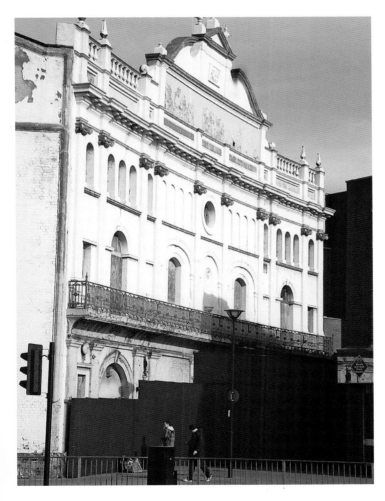

BECAUSE THE GRAND Theatre is hemmed in by the Frenchgate Centre it is no longer possible to obtain a photograph from the same location as that in the earlier image. Efforts continue to raise sufficient funds to restore this important theatre, which with a capacity of approximately 800, would enable it to host larger middle-scale productions. This photograph, taken in the spring of 2011, shows the sad state of the once impressive three-storeyed Baroque façade.

STATION ROAD, FACTORY LANE, ST SEPULCHRE GATE AND PRINTING OFFICE STREET

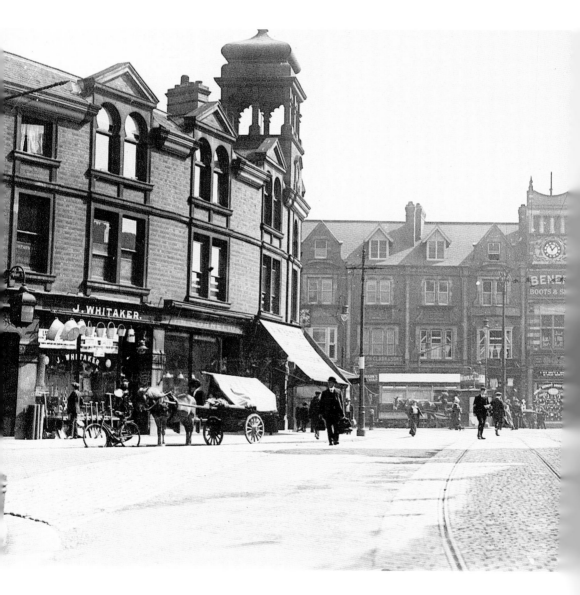

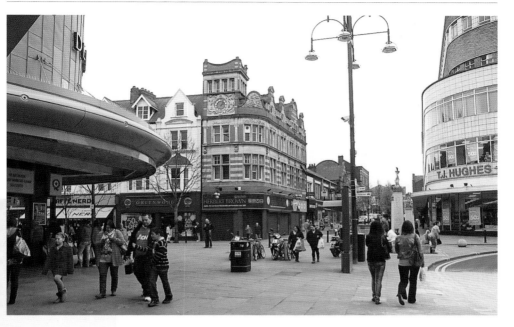

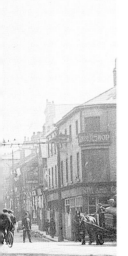

AN EDWARDIAN VIEW of Station Road and the junction of St Sepulchre Gate with Printing Office Street (left). The distinctive building with clock tower topped with finials was erected at the junction of St Sepulchre Gate and Printing Office Street in 1899 and is occupied by the Public Benefit Boot Co. Ltd. This famous firm traded from over 780 nationwide business premises from the 1870s to the 1970s. On the opposite corner of Printing Office Street is the grocery shop of Sanderson & Son. Printing Office Street, which faces Station Road, takes its name from having once housed the printing works of the *Doncaster Gazette*. Factory Lane cuts into Station Road and St Sepulchre Gate from the left, where a display of garden implements and various items of ironmongery can be seen outside J. Whittaker's shop. (*Courtesy of Chris Sharp*)

A MUCH ALTERED view is seen above, taken from as close to the location of the Edwardian image as possible. The Frenchgate Centre covers the site of both Factory Lane and Station Road. The distinctive red-brick building with lavish carvings, stone dressing and clock tower now minus its finials, is today occupied by the jeweller's Herbert Brown. The grocery shop occupied by Sanderson & Son was demolished in the late 1930s and replaced by the Co-operative Emporium, erected to the designs of local architects T.H. Johnson & Son. Subsequently occupied by the Danum Store these premises are now a branch of the department store TJ Hughes. West Laith Gate sweeps into the image from the right as it enters St Sepulchre Gate.

STATION ROAD, FACTORY LANE, ST SEPULCHRE GATE AND PRINTING OFFICE STREET CONTINUED

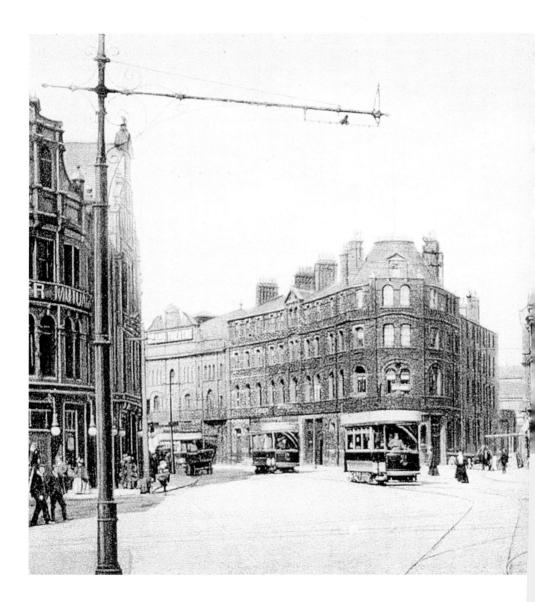

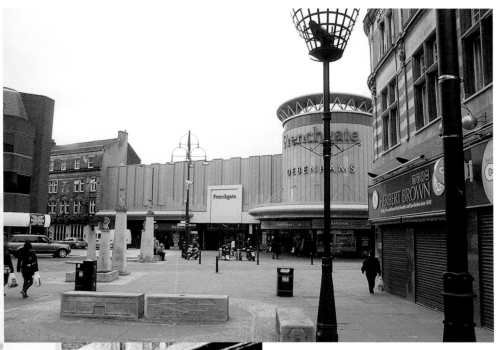

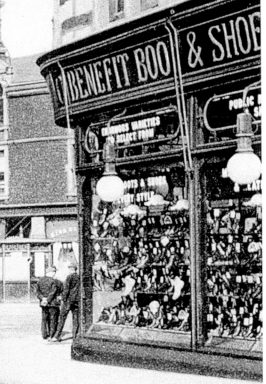

A REVERSE VIEW of the previous two images. Looking across St Sepulchre Gate to Factory Lane and to Station Road from Printing Office Street *c.* 1902 when trams rattled through Doncaster's streets, many terminating in Station Road.

A VIEW TAKEN from the same spot as the early twentieth-century image. Herbert Brown, jeweller and pawnbroker, was established in Leeds in 1840. Their Doncaster branch, situated at No. 47 St Sepulchre Gate occupies the former premises of the Benefit Boot Co. Ltd. The eastern end of St Sepulchre Gate West can be seen in the left foreground, where the gunmetal Range Rover is parked, and beyond West Laith Gate is St Sepulchre Gate on the right adjacent to the Frenchgate Centre.

ST SEPULCHRE GATE

ST SEPULCHRE GATE looking towards the junction of French Gate and High Street, *c.* 1912. Considered to be one of the grandest shops in Doncaster, and certainly the place to be seen shopping, Hodgson & Hepworth Ltd, whose premises can be seen in the left foreground, were established in 1872 as a grocery business. Richard Hodgson had previously been a tobacconist, and Richard Hepworth a provisions dealer. Hodgson & Hepworth's 'Ready Money Stores' soon expanded their ranges. Their St Sepulchre Gate stores housed a drugs department. Other lines included confectionary, tobacco and wines and spirits. In the days before metalled roads were commonplace, the need to polish one's boots and shoes or to have one's footman or valet undertake the task, must have been far more necessary than the general need is today. This particular image is one of several featured in this book showing the condition of Doncaster's

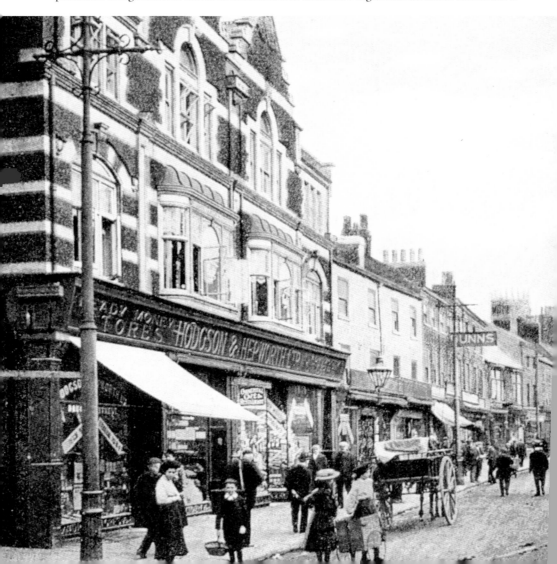

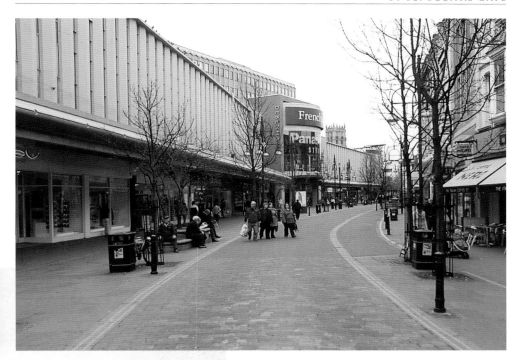

major thoroughfares well into the twentieth century, before motorised vehicles replaced horse-drawn traffic. The tower of St George's church can be seen in the centre background.

ST SEPULCHRE GATE seen in the spring of 2011 from a similar spot to the image taken nearly a hundred years previously. Only the distinctive tower of St George's church in the centre background is discernible in the vastly changed St Sepulchre Gate of today. When one compares the old image with the new, paying particular attention to the left-hand side where the Frenchgate Centre now stands, it does help one appreciate exactly how much Doncaster has lost, or indeed, as some might consider, gained, by the massive redevelopment that took place over four decades previously.

45

ST SEPULCHRE GATE AND WEST STREET

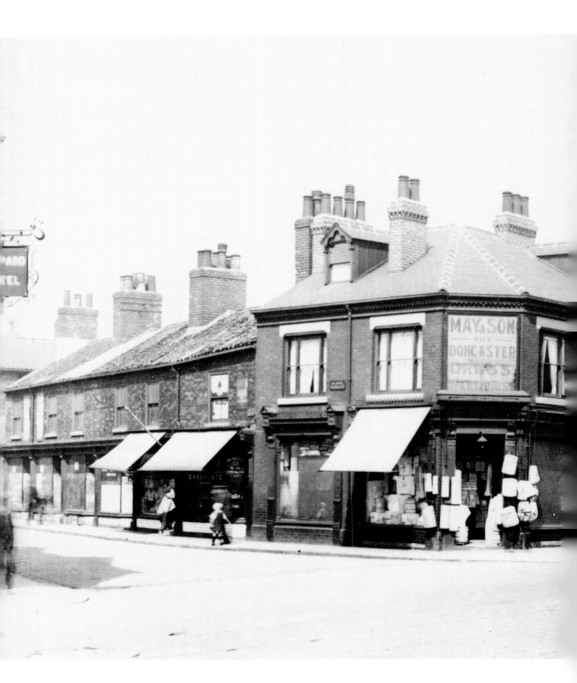

TOWARDS THE END of the last decade of the nineteenth century John May established a clothing business at No. 110 St Sepulchre Gate and in March 1908 moved to larger premises at 118–120 St Sepulchre Gate. This photograph, taken before the First World War, shows his shop, situated at the junction with West Street. The premises were rebuilt in the 1930s and suffered bomb damage in 1942. John May died in 1941. Members of the May family continued to trade until 1988, when the business closed. On the left can be seen the sign of the Leopard Hotel, which had been set back when West Street was widened in 1908.

THE SITE OF May's former premises is currently occupied by another clothing outlet, Bradley Knipe, a menswear dealer.

THE ESSOLDO,
SILVER STREET

A LATE 1940s view of Silver Street (left). The Essoldo, seen on the left, began its life as the Palace Theatre, also known as the Palace of Varieties, and was built by the architects Ward & Ball. It opened as the Palace in 1911 and staged live shows until 1920, when it became a cine-variety house. Eventually it became a fully fledged cinema which could accommodate 1,740 filmgoers, and changed its name to the 'Essoldo' in 1947. It closed in 1962 and was demolished in 1970. (*Barry Crabtree Collection*)

SILVER STREET IN the present day is dotted with nightclubs, discotheques and bars. There are also several restaurants and fast food outlets, interspaced with a few retail units.

SILVER STREET

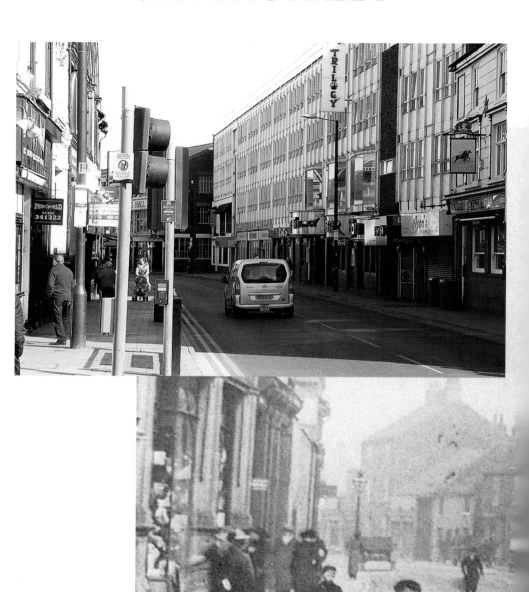

SILVER STREET LOOKING towards Sunny Bar, *c.* 1915 (below) . On the right-hand side of the image before the Palace Theatre are the St Leger tavern and the Palace Buffet.

A MUCH CHANGED Silver Street can be seen in the modern photograph on the left. The choice of entertainment and socialising has changed considerably for many of Doncaster's younger residents and visitors alike in recent years. More modern venues have been established and become associated with this part of town, which has been described as 'having a party atmosphere second to none, especially at weekends'.

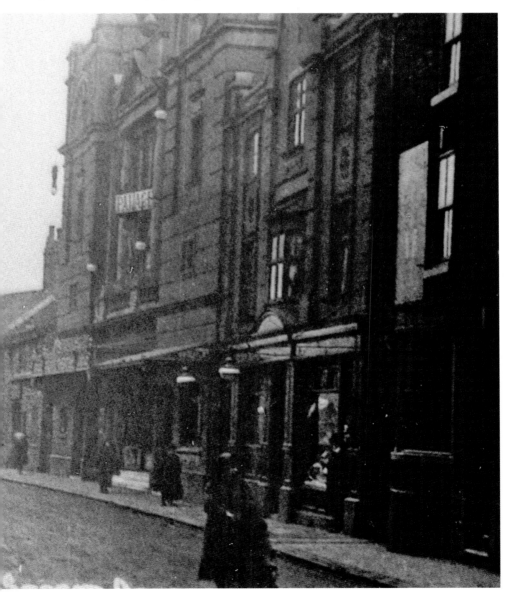

HALL GATE AND SILVER STREET

A POLICEMAN ON his beat crosses Hall Gate at the Silver Street junction, *c.* 1905. Daniel Pottergill's tobacconist's shop, which was demolished in 1912, fronted Hall Gate and had an abundance of advertising signs on its Silver Street gable. Mr Pottergill had occupied the premises since 1899. When the business closed prior to demolition he retired to Filey, where he died in 1924. (*Barry Crabtree Collection*)

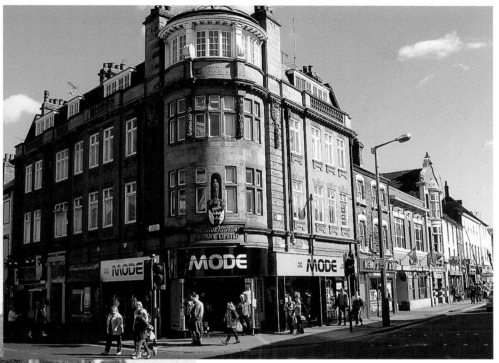

THE HALL GATE/Silver Street junction, seen here in March 2011. The Prudential Assurance Building, emblazoned with the company's coat of arms, on its stone dressed, curved corner frontage, was built on the site of Daniel Pottergill's shop. This elegant, unassuming building was designed by Paul Waterhouse (1861–1924), onetime president of the Royal Institute of British Architects and son of the famous Victorian architect Alfred Waterhouse. Its ground floor is now occupied by the clothing outlet, Mode. With the exception of the building to the right of Nemo's Fish Bar, most of the buildings (once elegant town houses) seen on the north-east side of Hall Gate, apart from their shopfronts, appear substantially unaltered.

THE THEATRE ROYAL AND MARKET PLACE

DONCASTER'S FIRST THEATRE was variously known as the Theatre Royal (from 1835, after the then Princess Victoria and her mother stayed nearby during part of race week), the Royal Opera House or more simply during its early years, the 'Theatre'. The corporation decided that the town lacked a fitting place of entertainment for distinguished visitors during Doncaster Races, so they invited William Lindley (*c.* 1739–1818) to design a playhouse. The first stone was laid on 28 April 1775, and the theatre was built in the Palladian style. Lieutenant-Colonel (later Major-General)

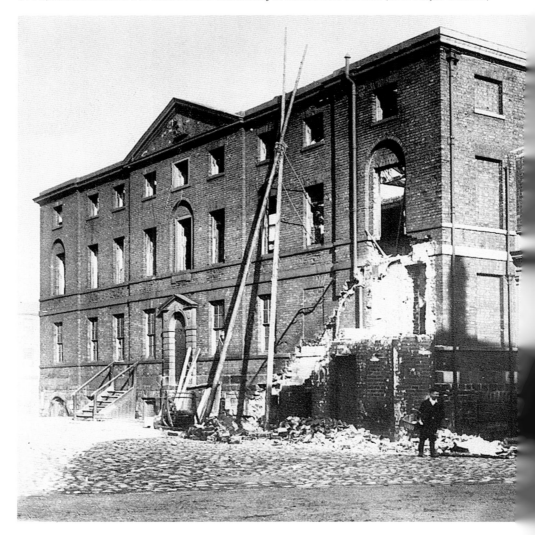

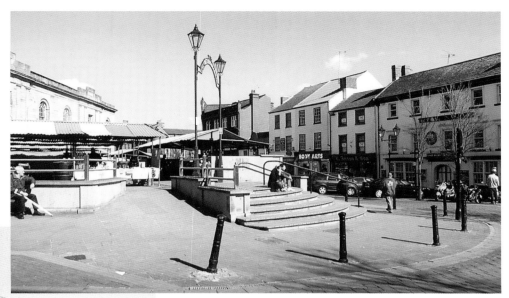

Anthony St Leger (1731/2–86), after whom Doncaster's famous classic turf race was named, helped make the venue an immediate success, after he secured the theatre's lease for his friend, the actor-manager Tate Wilkinson (1739–1803), who operated the York circuit of theatres. Here it is seen during demolition in 1900. The Theatre Royal's disappearance from the Doncaster landscape heralded the beginning of the demolition of many Georgian and earlier buildings in the town centre, whose destruction occurred during one of many such periods of wanton vandalism to many of the town's beautiful, important and best buildings, the first of which lasted for over a decade. The Woolpack Hotel, which dates from at least as early as the first decade of the eighteenth century, can be seen in the background to the right of the theatre.

TODAY THE SITE of the Theatre Royal forms part of Doncaster's extensive market, regarded as one of the finest traditional markets in all of England. The foundation stone of the Market Hall, seen on the left, was laid by Sir William Bryan Cooke of Wheatley Hall, in 1847. The Market Hall, also known as the International Food Hall, is the oldest building in the market complex.

MARKET PLACE

MARKET PLACE, C. 1908 (right), taken from the south side, close to the Woolpack Inn. The open market at the back of the neo-classical Market Hall of 1847 (seen on the right) covers part of the site occupied by the Theatre Royal, demolished some eight years previously.

MARKET PLACE, SPRING 2011 (below). In the right foreground beyond the bollards and where the open market stalls are situated, is the site of Doncaster's first theatre, demolished in 1900. The covered market beyond was attached to the

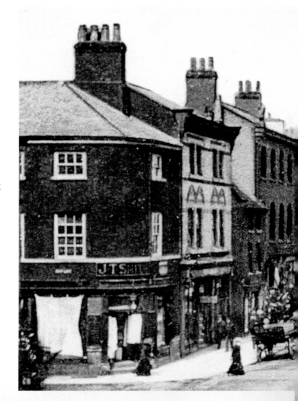

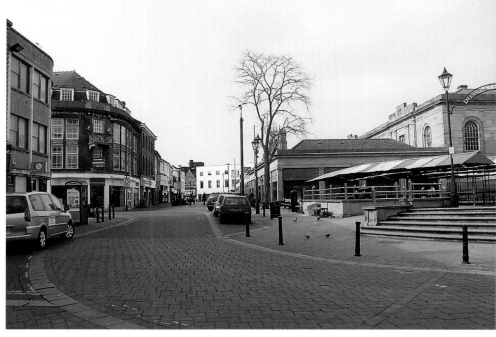

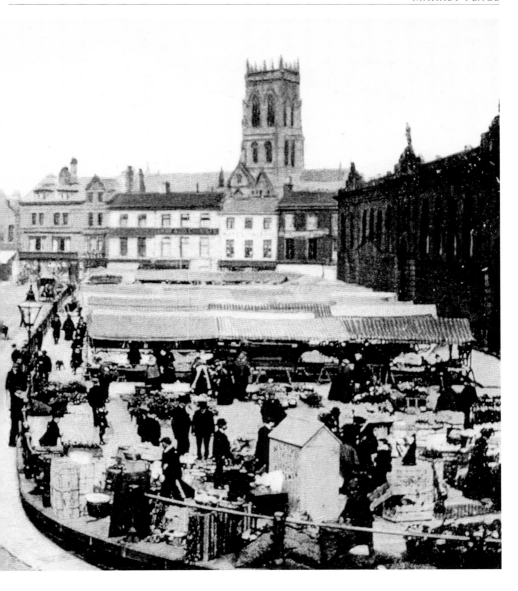

1847 Market Hall in 1920. It contains the Fish Market, one of Doncaster's popular attractions. There is a vast array of wonderfully displayed fish and shellfish available and nearby a wide range of fine cheeses, raw and cooked meat and game tempt the taste buds of local shoppers and visitors to Doncaster alike.

MARKET PLACE CONTINUED

THE SOUTH-WEST CORNER of Market Place, *c.* 1914. It is widely believed that a market existed in Danum during the Roman occupation. Doncaster was granted its first Royal Charter by King Richard I in 1194 and in 1248 the first Market Charter was granted. Over the centuries many different markets have flourished in Doncaster.
(*Barry Crabtree Collection*)

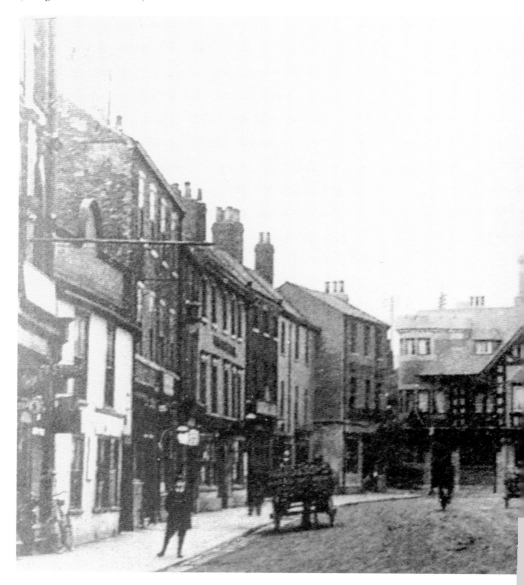

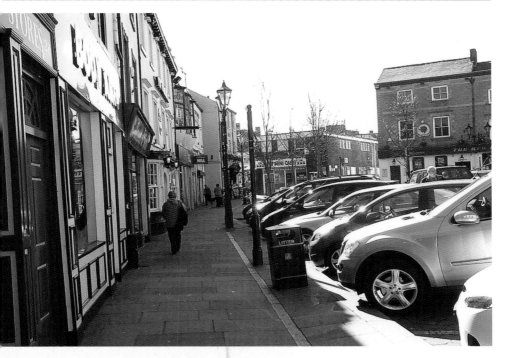

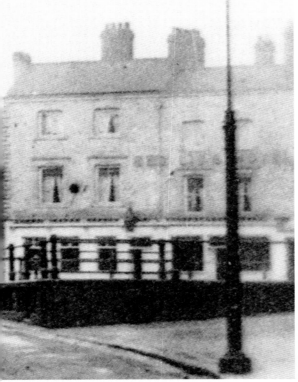

THE MOST NOTICEABLE change to this part of Market Place has been the disappearance of the Wellington Inn, which stood on the corner site to the left of the Red Lion. Market Place continues to be one of the town's busiest locations, as it has been for generations. Today Doncaster Market comprises several different markets all sitting side-by-side. These include the Wool Market, Outer Market and the Irish Middle Market. Triangular in shape, Market Place combines outdoor stalls with historic market buildings, offering for sale every conceivable type of fresh foods, fruit, vegetables, dry goods, clothing, crockery, fancy goods, original artwork, books, stationary, toys, mobility scooters, ironmongery, antiques and second-hand items.

WELLINGTON INN,
MARKET PLACE

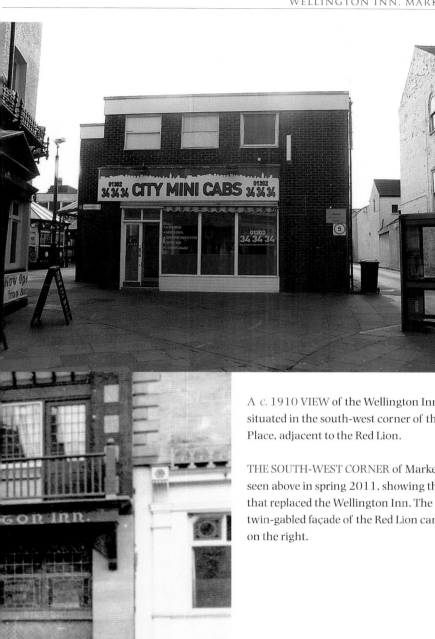

A *c.* 1910 VIEW of the Wellington Inn (left), situated in the south-west corner of the Market Place, adjacent to the Red Lion.

THE SOUTH-WEST CORNER of Market Place, seen above in spring 2011, showing the building that replaced the Wellington Inn. The south twin-gabled façade of the Red Lion can be seen on the right.

THE CORN EXCHANGE,
MARKET PLACE

THE CORN EXCHANGE, *c.* 1900. Opened in 1875 and constructed on a site adjacent to the Market Hall in a mixed Renaissance style to the designs of Lincoln architect William Watkins, with a sculpted panel over the main entrance depicting the Mansion House and the Guildhall. Below this,

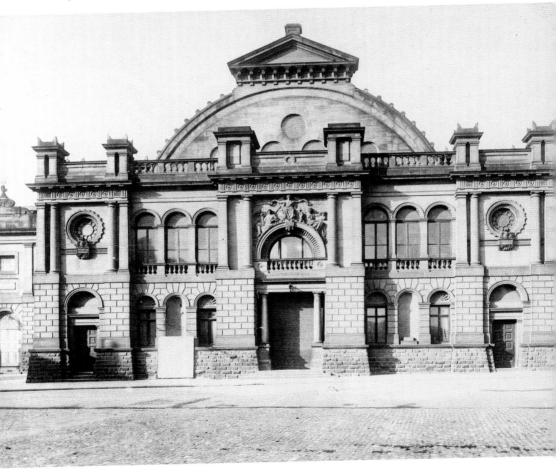

beneath the ornamental balustrade is the inscription 'WILLIAM COTTERILL, MAYOR, 1873'. There are two pairs of polished red granite Tuscan columns placed on either side of the entrance and six red sandstone Tuscan columns on the upper storey. From the outset, as well as being a trading centre, it was proposed that the Corn Exchange should also be an entertainment venue. Distinguished visitors have included a young Winston Churchill, who recounted his experiences

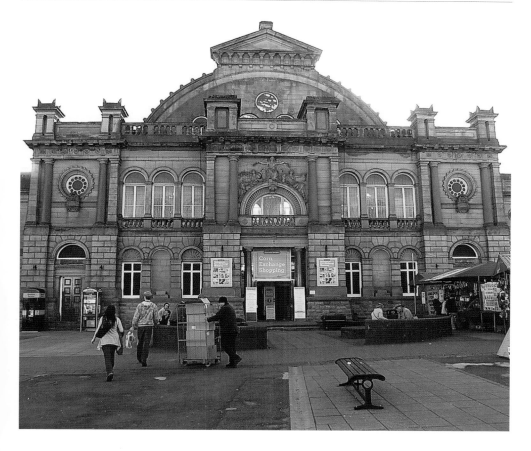

during the Boer War to an enthralled audience, and Sir Edward Elgar, who conducted the London Symphony Orchestra here in 1909.

SEVERELY DAMAGED IN a fire in the mid-1990s, the Corn Exchange has been restored and now serves as an indoor market, where craft stalls, artwork and various household goods are sold. On the upper level there is a tea room.

HALL GATE AND HIGH STREET

A SCRIVENS POSTCARD view of Hall Gate and High Street (right), as far as the Mansion House, before the First World War. Principally due to the growth of the coaching trade and agricultural expansion in the surrounding countryside, by the beginning of the eighteenth century, Doncaster's prosperity had increased considerably. Parts of Doncaster became a magnet for genteel people of independent means who were desirous to live in the town with its steadily increasing amenities, but also to be close to the fine sporting country that surrounded it. At the beginning of the century many of the town's most prominent citizens became resident in High Street but as

the century advanced so did the building of a considerable number of well-proportioned Georgian houses up Hall Gate, as far as Hall Cross Hill. Later houses were often faced in stucco (smooth render). Many of the houses built in Hall Gate itself have survived. Unfortunately by the time this photograph was taken several had ceased to be private residences. Some have had their attractive iron balconies removed, and their ground floors have been converted into shops.
(*Courtesy of Chris Sharp*)

PRESENTLY, ALTHOUGH SOME fine Georgian houses survive in Hall Gate, many pictured in the Scrivens image have been torn down and replaced by such excrescences as those in the left foreground. The second building in the right foreground is Down Quilt House, a Georgian survivor amid the 1960s redevelopment. Still in part an elegant street, the Hall Gate of today is but a shadow of its former self.

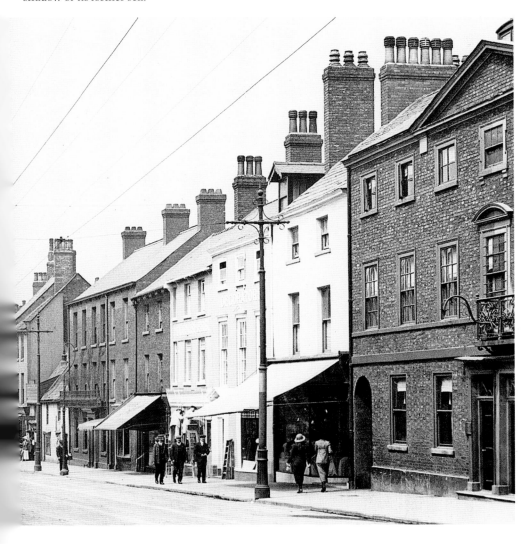

HORSEFAIR AND WATERDALE

HORSEFAIR AND WATERDALE, *c.* 1900. Dominating the centre background is the Old Holy Trinity Presbyterian church, which opened on 14 August 1892.
(*Barry Crabtree Collection*)

THE FORMER OLD Holy Trinity Presbyterian Church at 35 Wood Street was converted into a public house which opened in 1982. The public house has in turn closed. The building is now occupied by the Trinity nightclub. Occupying No. 41 Waterdale in the left foreground is Apple mini cabs, next door, at No. 42, with the distinctive first-floor bay windows is the Italian restaurant Opera Ristorante, and beyond that, with premises occupying both Waterdale and Wood Street, is Ward Brothers carpet and rug shop. Cabinet making brothers Fred and Tom Ward

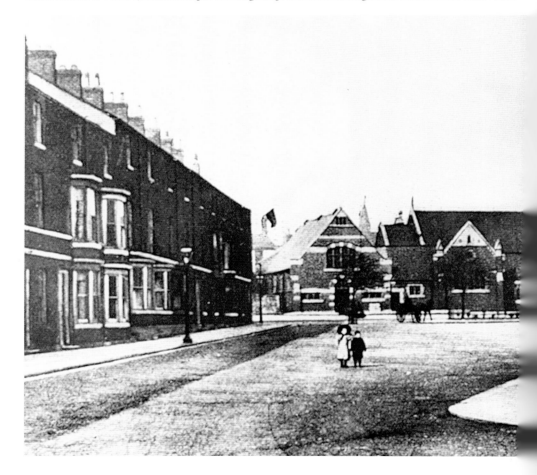

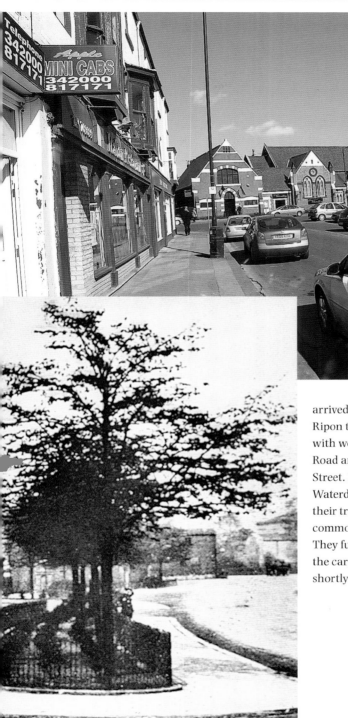

arrived in Doncaster in 1919 from Ripon to establish their business with workshops in Cemetery Road and showrooms in Rentick Street. In 1923 they moved to Waterdale and gradually expanded their trading premises to include commodious furniture showrooms. They further expanded to include the carpet and rug shop, seen here shortly before the Millennium.

WATERDALE

A 1920S VIEW of the Waterdale façade of the Girls' High School (right). The foundation stone of the Girl's High School was laid by Alderman H.H. Birkinshaw, on 24 February 1910. The school was built on the site of Chequer House in Chequer Road, and was officially opened on 3 October 1911. (*Courtesy of Chris Sharp*)

IN EARLY 2011 the Girls' High School has long stood empty and awaits redevelopment. The building beyond on the right is the Civic Theatre. Originally built as the New Arcadia in 1921 by theatrical producer and comedian Harry Russell, it became the Arcadia Picture House in the early 1930s.

Towards the end of the 1940s the building was purchased by Doncaster Corporation, who converted it into a theatre and cinema. Following a major refurbishment programme in the 1970s the building became Doncaster Civic Theatre, with a 495-seat single-storey auditorium and a proscenium arch stage. Every year over 70,000 patrons pass through its doors to enjoy a varied programme of entertainment, including the annual pantomime. The nondescript modern office building in the centre background, formerly the offices of the National Coal Board, is Consort House, part of which is currently occupied by the estate and letting agents Whitegates.

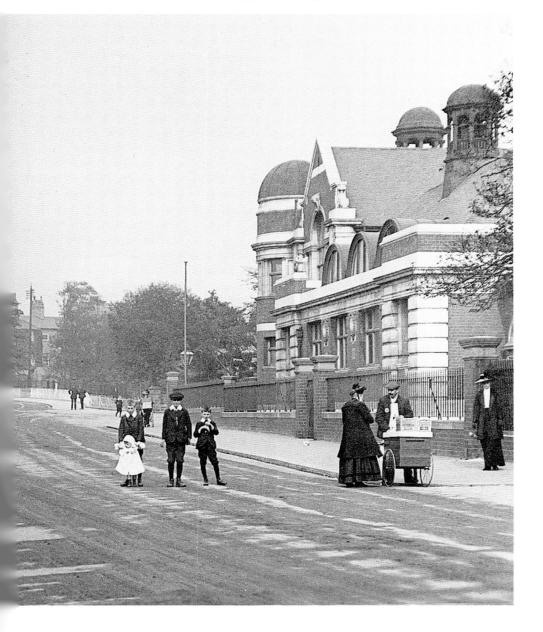

HALL GATE AND SOUTH PARADE

A VIEW FROM the northern end of Hall Gate across to South Parade, *c.* 1928. The cinema (on the left with the Doric columns) opened as the South Parade Cinema in 1920. Renamed the Majestic in 1922, it became part of the Gaumont circuit a few years later and survived until 1933 when the entire building was demolished and replaced by a cinema equipped with full stage facilities and

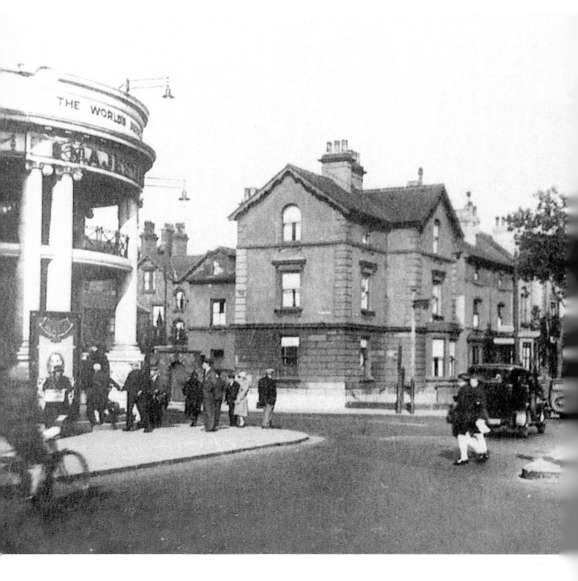

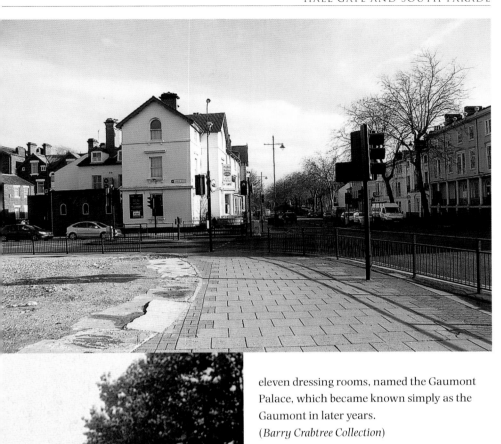

eleven dressing rooms, named the Gaumont Palace, which became known simply as the Gaumont in later years.
(*Barry Crabtree Collection*)

A VIEW OF the same location, seen above in March 2011. The gable of the Victorian Regent Hotel is featured on the left at the junction of Thorne Road and South Parade. Family-run since 1935, the Regent Hotel has fifty-three bedrooms and three conference rooms. The Beatles stayed here when they appeared at the Gaumont, situated across the road from the hotel. The framed visitors' book featuring signatures of the 'Fab Four' is a prized exhibit. In the right foreground can be seen part of Pillar House. This distinctive Georgian building, with its raised ground floor forming a colonnade, was where the Prince of Wales (later King George IV) lodged at the house of the architect William Lindley in 1808 when visiting Doncaster Racecourse.

71

SOUTH PARADE AND HALL GATE

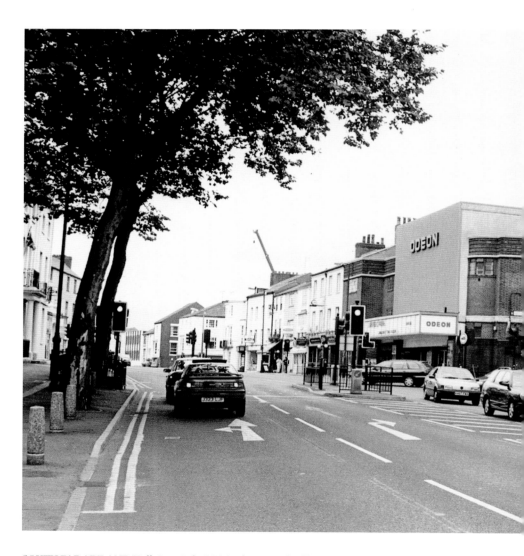

SOUTH PARADE AND Hall Gate, July 2001, photographed by Paul T. Langley Welch. The Odeon cinema, seen on the right, was known as the Gaumont until 20 January 1987, when it was renamed the Odeon. Acquired by Odeon in 1981, it was the last Gaumont to keep its name. It was designed by W.E. Trent and W. Sydney Trent and opened on 3 September 1934, with a capacity of 2,020. Opera was often presented at the Gaumont and during the 1950s and 1960s many well-known performers and pop groups, including Buddy Holly, the Beatles and the Rolling Stones, performed

there. Pantomimes and musicals were also a regular feature. After conversion to three screens in 1973, the capacity of the main auditorium was cut to 1,003 seats, with two mini-cinemas, each accommodating 144, located under the balcony. These modifications reduced the Gaumont's attraction as a live performance venue to some extent. During the period in my life when I was an impresario I presented a musical there myself in 1984. I had *The Wind in the Willows* on a 47-week national tour. The show's appearance in Doncaster occurred during the infamous miner's strike. A teachers' strike prevented any school parties attending and a local transport strike took place during that same week. Needless to say our appearance in Doncaster was not the most successful on record!

LIVE PERFORMANCES CEASED at the Gaumont towards the end of the 1980s. Thereafter, large-scale concerts became a feature of the Dome, opened in 1990 at Doncaster Leisure Park in Bawtry Road. Other cinema complexes opened elsewhere in Doncaster and despite the change of name to the Odeon, this once-thriving cinema gradually dwindled in popularity. The last film to be shown there featured Sean Faris in *Never Back Down*, on 10 April 2008. The building was eventually pulled down and its empty site, seen here in spring 2011, is awaiting redevelopment. The Regent Hotel is on the right and in the left foreground Pillar House can be seen.

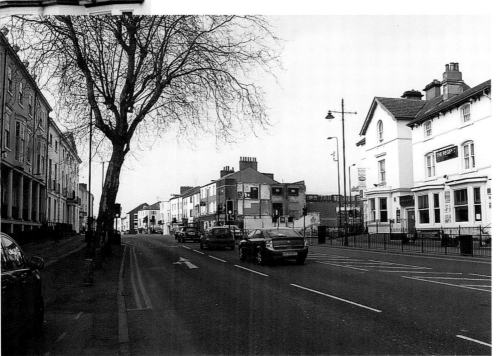

REGENT TERRACE AND HALL CROSS

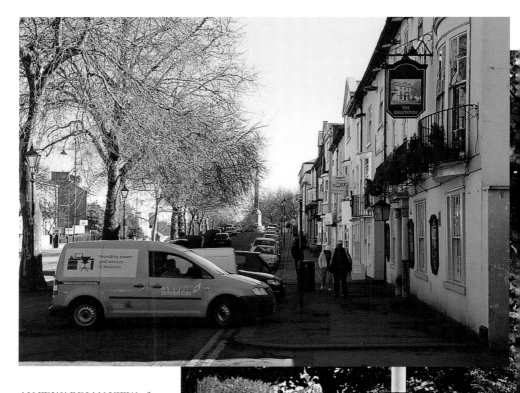

AN EDWARDIAN VIEW of Hall Cross and South Parade (right). Regent Terrace, located in Hall Cross Hill, is on the right. The monument known as Hall Cross, seen on the centre skyline, was erected in 1793 by architect William Lindley to replace a cross which once stood at the top of Hall Gate. The Salutation Inn (right) dates from *c.* 1778, and replaced an earlier inn of the same name. The arched entrance,

to the left of the sign advertising Pratt's Perfection Motor Spirit, was where stagecoaches once gained access to the stables at the rear.
(*Courtesy of Chris Sharp*)

HALL CROSS HILL viewed from a similar spot in spring 2011 (left). Fortunately, the buildings in Regent Terrace are largely unchanged. The exteriors of the individual houses have interesting features, from attractive bow windows, to ornate fanlights, door knockers, boot scrapers and intricate ironwork.

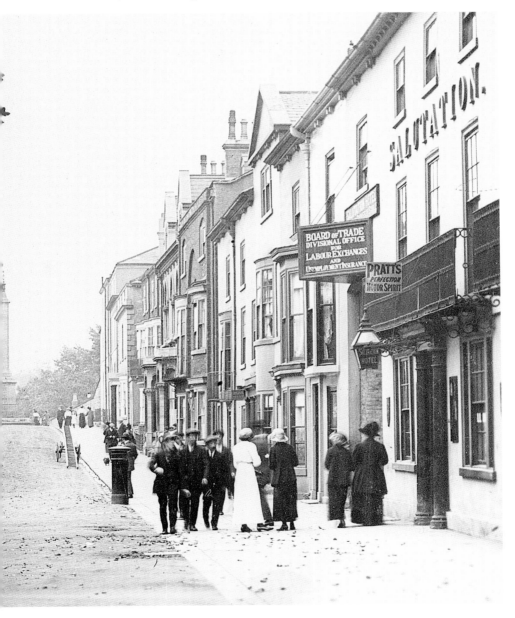

HALL CROSS HILL, REGENT TERRACE AND SOUTH PARADE

A *c.* 1950 POSTCARD view of Regent Terrace and South Parade viewed from Hall Cross Hill. According to Doncaster Civic Trust, Regent Terrace in South Parade, seen here on the left, is Doncaster's most complete historic street, where all the buildings are listed and, with the

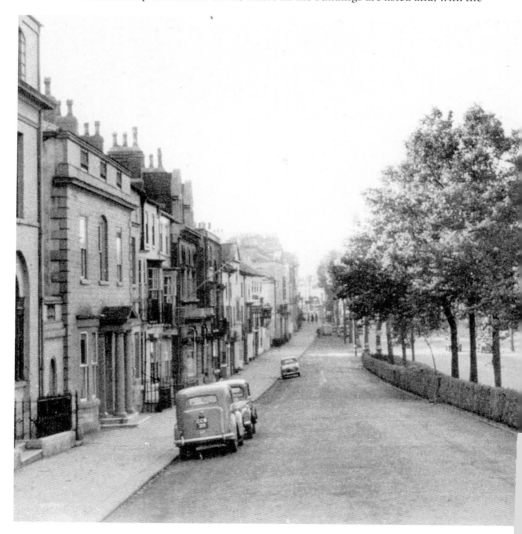

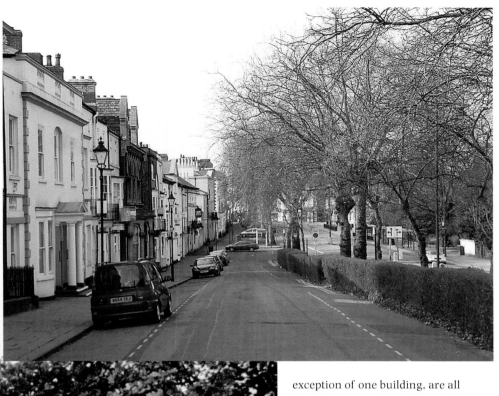

exception of one building, are all Georgian, many dating from *c.* 1800. The exception is No. 6A, a red-brick Victorian Gothic building of 1869.

REGENT TERRACE AND South Parade viewed from the base of Hall Cross in spring 2011 (above). The dark red-brick façade of No. 6A Regent Terrace, with its twin gabled dormers, can be seen beyond the pink and maroon estate agent's billboard. Under threat of demolition well into the twentieth century, Regent Terrace is an important survival.

BENNETTHORPE

A VIEW OF South Parade from Bennetthorpe towards Hall Cross and Regent Terrace, from the base of Doncaster war memorial. The wall surrounding Elmfield House can be seen on the left.

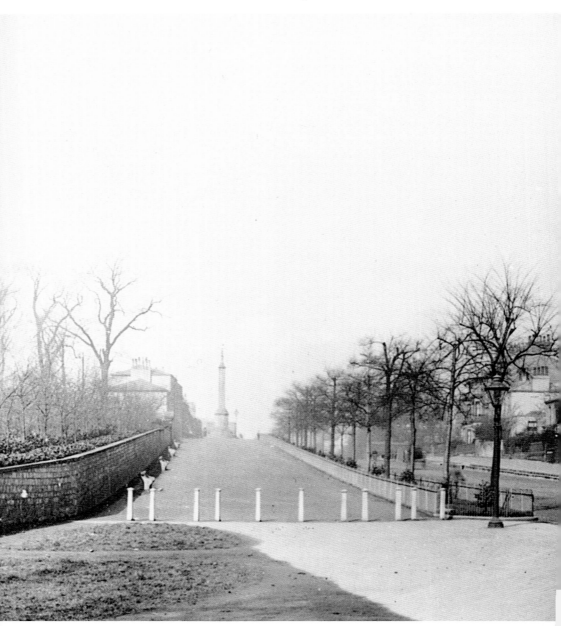

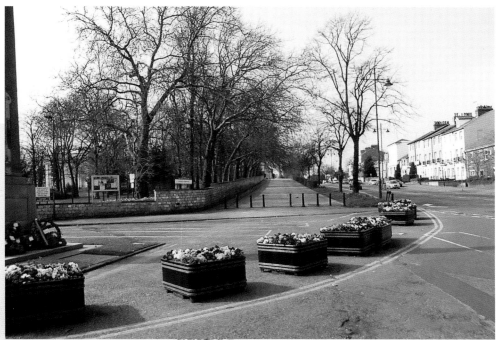

A VIEW OF South Parade, taken from a similar spot in early spring 2011. Part of Doncaster war memorial can be seen on the extreme left. The memorial was designed by J. and J.H. Pearson of Manchester and unveiled on 12 March 1923. It features a figure of 'Grief' mounted on an obelisk, adorned with wreaths near the top and a Greek key design at the base, with panels of low-relief carving around the plinth. At any time of year Doncaster is blessed with an abundance of planting, throughout the town centre and all around the periphery. The planting seen here is restrained compared to that during late spring and summer and early autumn, when the displays are particularly fine. Even the roundabouts dotted about the town and the approaches to it do not escape the meticulous attention that is paid to enhancing the town centre, and some large-scale awe-inspiring topiary and living plant sculptures can be seen at various strategic points.

BENNETTHORPE
CONTINUED

A TRAM HEADS down Bennetthorpe from South Parade on its way to Doncaster Racecourse
c. 1906.

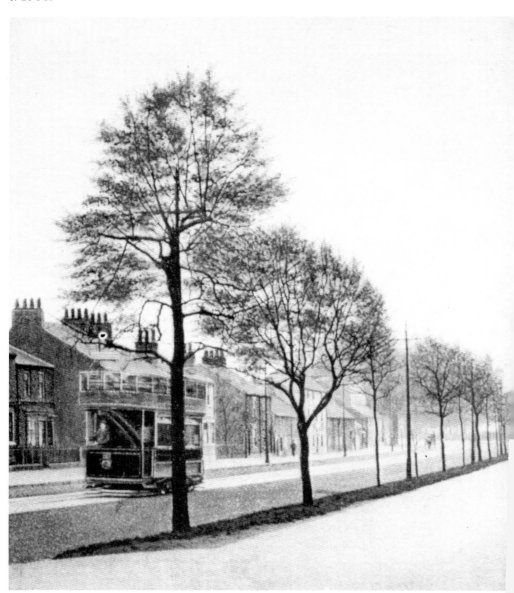

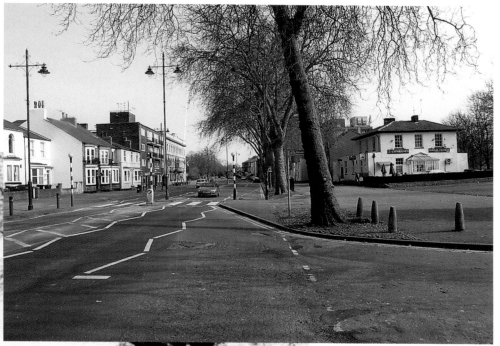

A PRESENT-DAY view taken from the same spot (above), which is adjacent to Doncaster war memorial, out of sight to the right. The white, well-proportioned early nineteenth-century building houses the Comrades Social Club, and on the left, the last building in view is the very elegant Rockingham Arms.

DONCASTER RACECOURSE

AT THE ENTRANCE to the racecourse in the 1890s. The pond was known as Common Pond or Horseshoe Pond, on account of its shape. The purpose of the pond was to allow the wooden-wheeled wagons and carriages passing along the Great North Road to drive through the water, causing the wheel rims and spokes to swell, which prevented squeaking and wear. The building on the left was

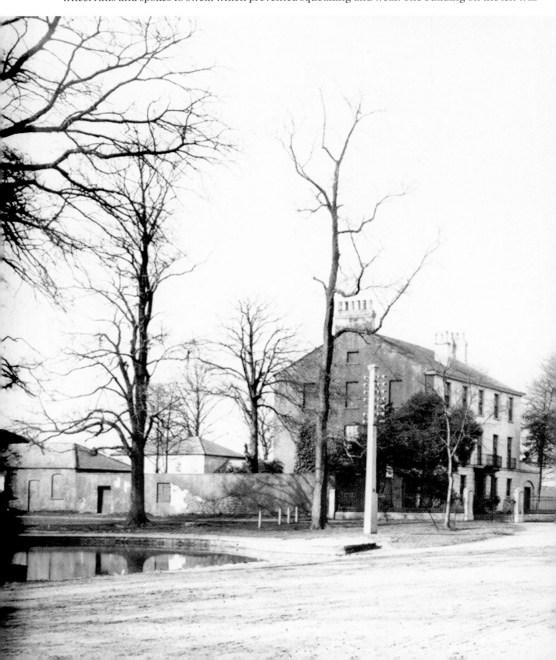

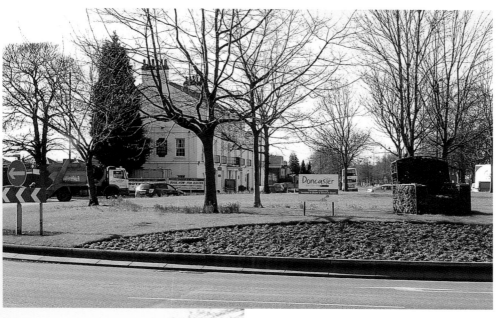

built in 1811 as the Turf Inn by Alderman Lockwood for John Henry Maw, on land known as Haigh's Close. However, rather than the intended inn, it became the private residence of John Henry Maw and remained in use as a private residence until 1854, when it was purchased by the county. The building became home to the West Yorkshire Regiment of Militia until 1882, when it again passed into private ownership. From 1920, Belle Vue House, as the building became known (named after the area in which it situated), was used to accommodate stable hands.

HORSESHOE POND WAS swept away during road improvements in the 1920s. Its position is now occupied by the junction of Carr House Road and the Great North Road at Racecourse Corner. In 1980, the race committee having by then provided new accommodation for the stable lads, Doncaster Metropolitan Borough Council decided to offer Belle Vue House for sale. It was converted to the Grand St Leger Hotel which opened in 1984.

LEGER WAY AND DONCASTER RACECOURSE

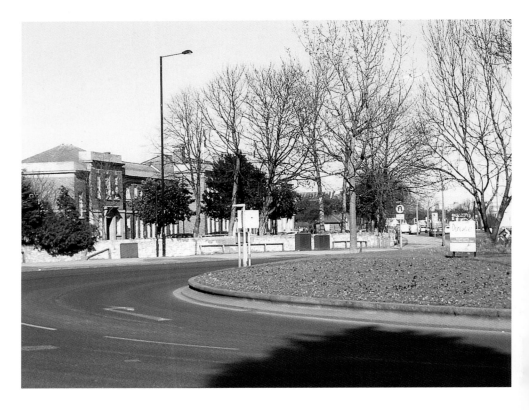

LOOKING ACROSS HORSESHOE Pond to Leger Way, c. 1905 (right). Doncaster Racecourse is on the right. Horse racing has been a feature of Doncaster for over 400 years. Records refer to racing there as early as 1595. Racing continued and reached greater prominence around the beginning of the eighteenth century and was supported by the Doncaster Corporation. In 1766 the Doncaster Gold Cup was instituted and this raised the status of racing in Doncaster significantly. It is the St Leger that has made Doncaster Racecourse one of the most famous in the world however – even though the race played second fiddle to the Gold Cup for its first few years. When what is now known worldwide as the oldest classic turf race was first run, it was simply entitled 'A Sweepstakes of 25 Guineas'. The St Leger Sweepstakes, to give the race its proper name (or 'Sellinger Sweepstakes' if one uses the correct pronunciation of the family name) was not actually given a name until its third year. It was first run on Cantley Common, and was won from a field of five horses by 'Allabaculia', a brown filly owned by the Marquess of Rockingham. The second horse past the post in this first race was owned by a military gentleman by the name of Lieutenant-Colonel St Leger of Park Hill.

THE ST LEGER was named at what has been variously described as a breakfast or a dinner, held between the 1777 and 1778 race meeting. Among the interested parties present were the Marquess of Rockingham and Lieutenant-Colonel St Leger. When it was proposed that the race should be named the Rockingham Stakes, Lord Rockingham, one of the greatest patrons of the turf in the eighteenth century, replied: 'No it was my friend St Leger who suggested the thing to me – call it after him.' Charles, 2nd Marquess of Rockingham (1730–82), whose palatial home Wentworth Woodhouse is situated just a few miles from Doncaster, was a greatly loved 'Whig', and twice held office as prime minister. The first 'official' St Leger, run on the new course at Town Moor, seen here on the right of Leger Way, was won by 'Hollandaise'. The building on the left belongs to the Doncaster Deaf Trust and incorporates a school, college and nursery.

CHRIST CHURCH

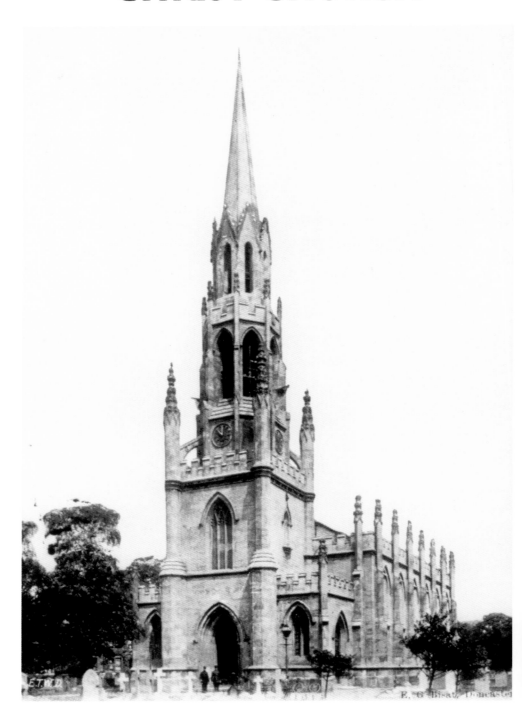

CHRIST CHURCH IN 1905 (left). A citizen, John Jarratt, for the building of Christ Church. The Mayor of Doncaster, Richard Littlejohn, laid the foundation stone on 9 October 1827 and the building, in limestone ashlar with a slate roof, was completed in 1829 to the designs of William Hurst. The chancel was enlarged in the 1850s by Sir Gilbert Scott. The spire was damaged by lightning and became so unsafe that it was taken down in 1918 and was not rebuilt until 1939, when a new, shorter spire clad in copper was added.

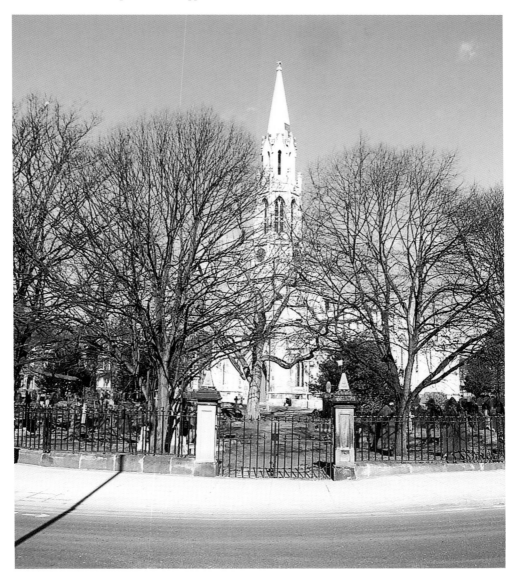

CHRIST CHURCH SEEN here in February 2011, showing the splendid copper spire which replaced the original.

THORNE ROAD

AN EARLY TWENTIETH-CENTURY postcard view of Thorne Road. The trees in the right foreground stand in the churchyard of Christ Church.
(*Courtesy of Chris Sharp*)

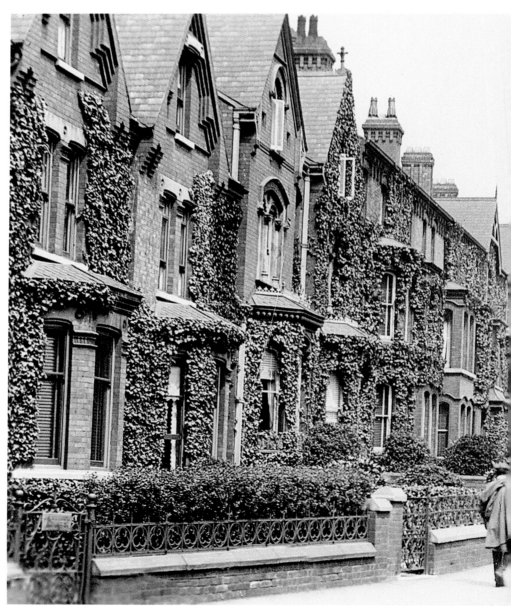

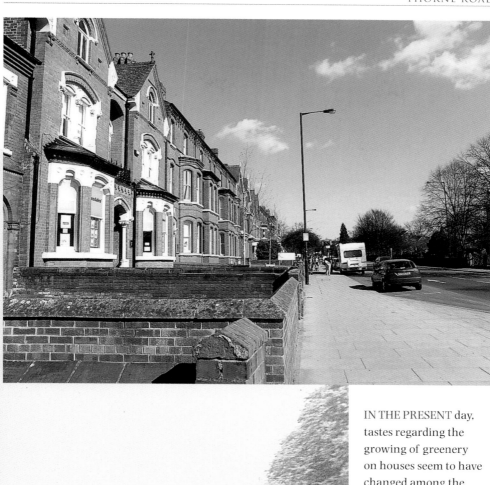

IN THE PRESENT day, tastes regarding the growing of greenery on houses seem to have changed among the residents of Thorne Road. Most of the houses are still used for residential purposes, while others, such as that in the left foreground, are being used for commercial purposes.

THE NORTH BRIDGE

IN 1908 WORK commenced on the building of a bridge to span the Marsh Gate railway crossing. Known locally as the New Bridge, and officially as the North Bridge, it was designed by the engineer Edward Parry and constructed by the local firm H. Arnold & Son. The bridge was officially opened on 11 February 1910.
(*Barry Crabtree Collection*)

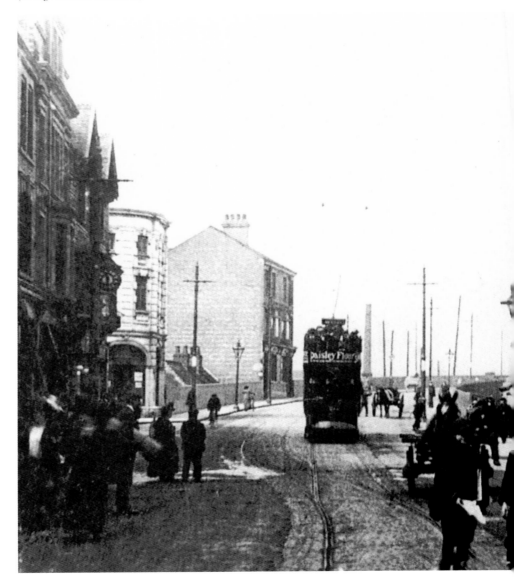

A CONTEMPORARY VIEW of the North Bridge taken from the same spot as the previous image.

DONCASTER RAILWAY STATION

DONCASTER RAILWAY STATION, 1898. The station was built in 1849 and replaced a temporary structure erected a year earlier. The busy forecourt is packed with hansom cabs, growlers, landaus and wagonettes. On the right can be seen a hut in which meals for the cab drivers were prepared. Surprisingly Doncaster has only ever had one railway station, even though in 1853 the Great Northern Railway made the town the headquarters of their engine and coach-building plant.

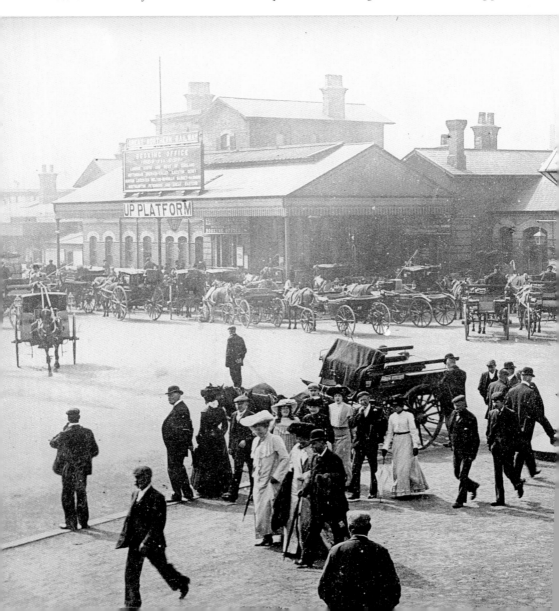

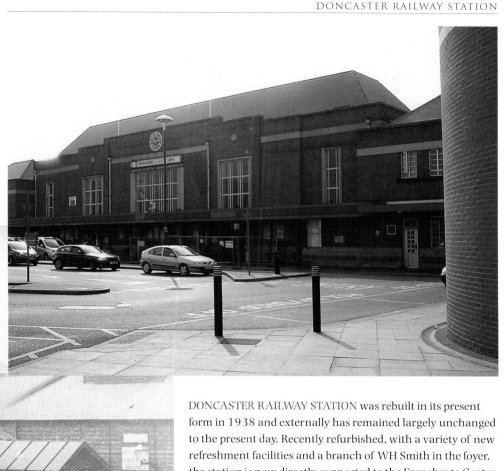

DONCASTER RAILWAY STATION was rebuilt in its present form in 1938 and externally has remained largely unchanged to the present day. Recently refurbished, with a variety of new refreshment facilities and a branch of WH Smith in the foyer, the station is now directly connected to the Frenchgate Centre extension, making access to the bus station and town centre amenities much easier.

DONCASTER RAILWAY STATION CONTINUED

DONCASTER RAILWAY STATION in the early 1900s.
(*Barry Crabtree Collection*)

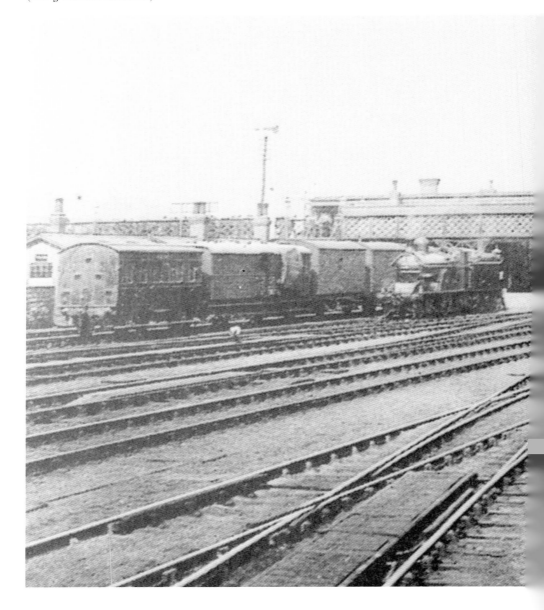

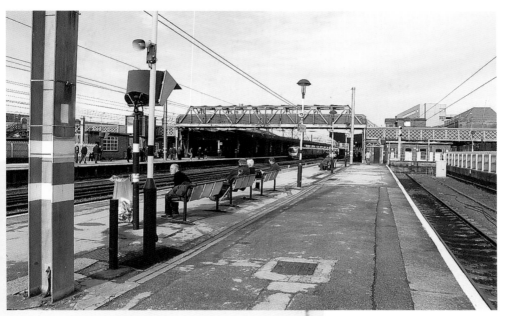

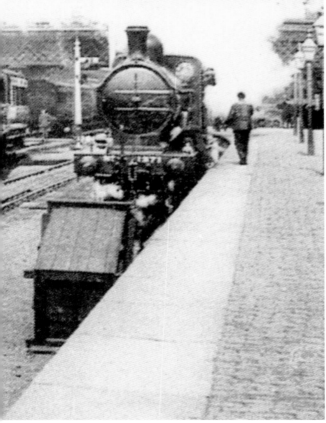

DONCASTER RAILWAY STATION in 2011 (above). The station has eight platforms. On the right is platform 2 and to the right of the dividing fence a train is about to leave platform 1. Platforms 1, 3, 4 and 8 take through trains. Trains terminate and start from platforms 2 and 5 (with south-facing bays) and at platforms 6 and 7, which have north-facing bays.

Other titles published by The History Press

Voices from Doncaster Plant Works
PETER TUFFREY

Doncaster's Plant Works was established in 1853 by the Great Northern Railway Comp
It has built and repaired numerous carriages, wagons, and locomotives including the
renowned *Flying Scotsman* and *Mallard*. Packed with photographs, many previously
unpublished, and assembled from interviews with many of its staff over the years – fror
managers, fitters, electricians, secretaries and canteen staff – this book is sure to appeal
railway enthusiasts, local history buffs and past and present Plant Works staff alike.

978 0 7524 5498 6

Racing in Doncaster
PETER TUFFREY

Racing in Doncaster contains a fascinating selection of photographs, charting the ups ar
downs of this historic course. Famous races, horses, jockeys and trainers can all be four
here, along with much detail about the St Leger, Doncaster's most celebrated and lucrat
race of all. This is must-have for all racing enthusiasts.

978 0 7524 5342 2

A Century of Doncaster
BRIAN ELLIOT

This wonderful selection of photographs illustrates the extraordinary transformation t
has taken place in Doncaster during the twentieth century. Many aspects of Doncaster
recent history are covered, famous occasions and individuals are remembered and the
impact of national and international events is witnessed. The book provides a striking
account of the changes that have so altered Doncaster's appearance and records the
process of transformation.

978 0 7524 8863 9

Doncaster Shops & Streets: Through the Lens of Luke Bagshaw
PETER TUFFREY

This fascinating collection showcases some of the very best of local photographer Luke
Bagshaw's images of Doncaster at the turn of the last century. Each photograph is
accompanied by a detailed caption giving the full history of the shop or scene. With mo
than 190 images of stores, street scenes, new buildings and the trams and carriages of
yesteryear, this book captures the Doncaster of the past. It is an essential guide for love
of photography and for anyone with an interest in the history of the area.

978 0 7524 4837 4

Visit our website and discover thousands of other History Press books.

www.thehistorypress.co.uk

The Histor Press